DORSET RAILWAYS

THROUGH TIME

Mike Phipp

AMBERLEY

Acknowledgements

Thanks to my colleagues Tony Guest and Steve Rhymes for their help with photographs, and thanks to my wife for her continued task of proofreading.

First published 2023

Amberley Publishing
The Hill, Stroud, Gloucestershire, GL5 4EP
www.amberley-books.com

Copyright © Mike Phipp, 2023

The right of Mike Phipp to be identified as the Author of this work has been asserted in accordance with the Copyrights, Designs and Patents Act 1988.

ISBN 978 1 3981 0854 7 (print)
ISBN 978 1 3981 0855 4 (ebook)

British Library Cataloguing in Publication Data.
A catalogue record for this book is available from the British Library.

Typesetting by SJmagic DESIGN SERVICES, India.
Printed in Great Britain.

Contents

Introduction

Railway mania hit Great Britain in the 1830s/40s and the south coast was not going to be left out. Many companies had grand plans, with London and southern counties seeing many companies spring up, but few got as far as constructing a line. Dorset was part of the railway routes expansion, being part of a planned London & South Western Railway route from London to the West Country. As always, plans change, and the main route into Dorset would eventually serve Bournemouth and Dorchester. A later L&SWR route to the West Country passed through part of the northern part of Dorset. The Great Western Railway also ventured into the county, with a line from Yeovil southwards to Weymouth. Both railways built a number of branch lines, the county also being traversed by the Somerset & Dorset Railway. There were no industrial areas to be served, the railways relying on passengers – both commuters and holidaymakers.

There is a pattern to the layout of the photos used in the book. Starting with Castleman's Corkscrew entering Dorset, then on through Wimborne and Wareham to its original terminus at Dorchester. We then follow the Great Western line, switching to the south-west of England's main line, taking in its two Dorset stations. Then a brief trip down the Somerset & Dorset to Poole before taking the present main line eastwards through Bournemouth and Christchurch, just prior to crossing the county border again.

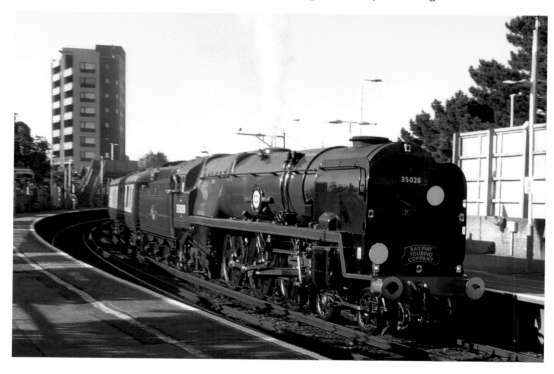

1. The Dorset Main Line – Castleman's Corkscrew

One of the railway companies to appear in the 1830s was the London & Southampton Railway, which was formed on 25 July 1834 to build a line between the capital and the major south coast port. Construction commenced in 1835, with the line opening on 11 May 1840. Prior to that the company had been renamed the London & South Western Railway (L&SWR) in July 1839. Initially, their London terminus was situated at Nine Elms – Waterloo not opening until July 1848. The terminus at Southampton was close to the docks, later being named Southampton Docks station and then Southampton Terminus.

In February 1844, Charles Castleman – a wealthy solicitor from Wimborne – proposed an extension of the line from Southampton to Dorchester. He approached the L&SWR, but they were not interested, as at the time they were thinking of a line to Exeter via Salisbury. Castleman planned on his line eventually reaching Exeter, so did not want the L&SWR building a competing line. Instead, he approached the rival Great Western Railway (GWR), who were interested in the route from Dorchester to Southampton. This did not please the L&SWR as they considered Southampton to be their territory. In January 1845, the Board of Trade's Railway Board dictated that the new line, when built, should be leased to the L&SWR and not the GWR. Along with the GWR agreeing not to be associated with the line, the L&SWR agreed to give up ideas of reaching Exeter. July 1845 saw the formation of the Southampton & Dorchester Railway, which in November that year granted a lease of the proposed line to the L&SWR for 999 years. On seeing the early plans Weymouth Council were unhappy that their town was not included, with the Southampton and Dorchester saying the town would be served 'somewhen'. As the driving force, Castleman had some say in the route of the new line, which also fell under the scrutiny of the New Forest Commissioners, who did not want a railway within their boundaries. As a result, when the line left a new station at Southampton it travelled south-westerly but omitted Lyndhurst and ended up to the south of it at Brockenhurst. The present-day main line continues from Brockenhurst, through New Milton, Bournemouth and Poole. But back in 1846 Bournemouth was still a small settlement surrounded by heathland. So, Castleman arranged for the new line to deviate northwards, taking in the towns of Ringwood and Wimborne before passing through Wareham and ending up at Dorchester. Construction was cheaper than building tunnels and earthworks on a more direct route.

Crossing the Dorset border shortly after Ringwood, Wimborne was reached next, having a substantial station and goods yard to serve the busy market town. It became an important junction from 1874 when the Somerset & Dorset Railway completed its line from Bath. Between Wimborne and Wareham the route meandered through the Dorset heathland, resulting in the whole route later being nicknamed 'Castleman's Corkscrew'. Despite this name, most of the route was decided by Captain Moorsom – the company's engineer. As Poole was not on the route, a branch was built from Poole Junction (now Hamworthy) to Poole (Ballast Quay), with a station close to Poole Bridge. The town had long been a port, but its maritime trade was in decline; this was not helped by the arrival of the railway, which now carried much of the goods. At Wareham, a small station was situated some way from the town. Stations were provided at the villages of Wool and Moreton before reaching

Dorchester. Wool station was built adjacent to where the Dorchester turnpike road crossed the River Frome. Moreton served the even smaller villages of Moreton and Crossways. Although Dorchester was the county town, its population was smaller than Weymouth or Poole, but it was provided with an impressive station. Through services to Dorchester were set to commence on 1 June 1847 – initially with five trains a day. A tunnel collapse at Southampton in May caused a delay in early services, with through running to Dorchester commencing in August. A typical timing was Nine Elms 9:00, stop at Southampton at 12:35, then reach Dorchester by 3:40. Not unexpectedly the Southampton & Dorchester was taken over by the L&SWR on 11 October 1848, with Castleman joining as a director. He also briefly served as chairman from 1873 to 1874. The L&SWR arranged for the track between Brockenhurst to Wimborne to be doubled in September 1858, then to Dorchester in August 1863.

Over the years a number of branches were added to the main line. Originally proposed in 1857, the Ringwood, Christchurch & Bournemouth Railway was finally formed in August 1859 to connect the towns. There were delays, with a single-track line from Ringwood to Christchurch not coming into use until 13 November 1862. There were five trains daily, rising to nine by the 1880s, all operated by the L&SWR, with the initial Christchurch station built east of Bargates. An intermediate station was provided at Herne (renamed Hurn from 1897), but there was little traffic. By this time Bournemouth was beginning to grow, but there was opposition to the idea of a rail connection. So it wasn't until 1870 that the railway arrived – the same year that Bournemouth had grown enough to be officially known as a town.

The Christchurch line was extended westwards to a small station built in an undeveloped area of Bournemouth to the east of Holdenhurst Road. Confirmation of its opening was kept quiet, with only two days' notice being given of services commencing on 14 March 1870. Trains from Waterloo would divide at Brockenhurst, with half the coaches going forward to Weymouth and half to Bournemouth. Timings between Waterloo and Bournemouth averaged three and a half hours. The arrival of the railway saw a flurry of building activity in Bournemouth and a great increase in its population – from 13,160 in 1871, rising to 52,980 in 1901 – the L&SWR soon realised its station was not large enough. The Ringwood, Christchurch & Bournemouth Railway was bought out by the L&SWR in January 1874.

The Salisbury & Dorset Junction Railway was formed in July 1861 to build a line from Salisbury to the south coast. Work commenced on the northern section in February 1863, but it was not until 20 December 1866 that services commenced, connecting with the L&SWR line at West Moors. Daggons Road was the first station on the line within Dorset, serving the nearby village of Alderholt; next was Verwood, another small village. Originally there was no station at West Moors. It did not open until 1 August 1867, originally as West Moors Junction and serving just a few rural dwellings. The plan was for the Salisbury & Dorset line to continue southwards with branches to Bournemouth and Poole. Lack of finance prevented these extensions, although there was still talk in 1878 of a Bournemouth direct railway from West Moors to the town. Services over the Salisbury line were operated by the L&SWR, who absorbed the Salisbury & Dorset Railway in August 1883. The line was never busy. In the early days there were only five services a day, plus a small amount of goods. During the 1920s there were six daily services from Salisbury to Bournemouth West, but only one on Sundays. This increased to nine and three in the 1930s, with the line also used by through trains from Cardiff. Following the Second World War, passenger services from Salisbury to Bournemouth were frequently hauled by Class T9 locomotives, with Class 700s in charge of goods traffic. Summer Saturdays in the 1950s saw longer-distance services use the line, such as New Milton to Swansea and Bournemouth West to Cardiff.

Local services were now hauled by Class U or Standard Class 76000s. West Moors had a RAOC Army Petroleum Depot constructed at beginning of the Second World War, with further sidings within the depot added in 1943.

The original Poole station was not in the best location as it was situated on the Hamworthy side of Poole Quay. Passengers then had to cross a rickety wooden toll bridge to reach the main town. Various new connections were proposed from the 1860s, including one from the original station on a viaduct over the town and on to Bournemouth. In 1866, the Poole & Bournemouth Railway planned a line from the L&SWR main line into Poole. The L&SWR also had its ideas for Poole, which included a bridge over the High Street and continued on an embankment to the east. By 1871 the plans showed level crossings, which have resulted in traffic problems ever since. After delays, the Poole & Bournemouth Railway completed the branch with services operated by the L&SWR. Opened on 2 December 1872, the new Poole station was connected to the L&SWR line in an area of heathland at a new station named New Poole Junction. Housing soon developed around the station and the area eventually became Broadstone. The L&SWR obviously anticipated an increase in business as New Poole Junction was provided with four long platforms. After many name changes it finally settled on Broadstone in July 1929. The original 1847 Poole Junction station was now renamed Hamworthy Junction. Passenger services continued from there to the original Poole station for a while but were withdrawn in 1896. However, the branch remained important for goods traffic to Hamworthy Quay. Poole Quay was served by a tramway from the new Poole station, coming into use in the summer of 1874. During the First World War extensive sidings for use by the military were built alongside the tramway, adjacent to Holes Bay. Throughout the majority of its life the line was the preserve of B4 tanks. Regulations dictated that the train was proceeded by a flagman to warn traffic and was limited to 4 mph.

In 1874, the Bournemouth & Poole Railway extended their branch eastwards towards Bournemouth to supplement the existing L&SWR line into the town from Christchurch. Poole station was situated on a sharp curve in the centre of the town, with a goods yard later provided to its west. The line continued to Parkstone, serving the eastern suburbs of Poole, and then to a new terminus at Bournemouth West. This was slightly closer to the expanding town than the one at Holdenhurst Road, which was now renamed Bournemouth East. The extension to Bournemouth West was opened on 15 June 1874 and, as well as L&SWR trains, was served by the Somerset & Dorset. The L&SWR bought out the Poole & Bournemouth Railway in October 1882.

Various plans were proposed for a line to Swanage. Eventually the Swanage Railway was formed in July 1881 to build a branch from Wareham to Swanage Pier. During the 1800s the town was a port for the local stone quarries, with much shipped to London via a tramway system alongside the pier. Despite the eventual coming of the railway, much of the stone continued to be shipped by sea. The town was also a popular holiday resort for the wealthy. The line opened on 20 May 1885 into Swanage station, which was situated close to the sea front. However, the additional section to the pier was never completed. With the opening of the branch the original Wareham station was replaced with the present one, which came into use in April 1887, although still some way north of the main town. Services were operated by the L&SWR, who formally absorbed the Swanage Railway in June 1886. Locomotives such as Beattie Well Tanks and Adams 'Radial Tanks' appeared on services, with Jubilees on longer trains. In the early 1900s sidings were added at Furzebrook to meet the existing narrow-gauge Pikes Tramway, which served the local Purbeck Ball Clay Pits. There were substantial amounts of clay to be found in Dorset, a number of the pits having rail connections.

Although the L&SWR agreed in January 1845 not to seek a route to Exeter, the Southampton & Dorchester Railway stated that it considered extending its line westwards to Exeter. In addition, 1846 saw the formation of the Exeter, Dorchester & Weymouth Junction Coast Railway, but nothing ever came of it. Their plan had been for a line between Exeter and Dorchester, with a branch to Weymouth diverging at Litton Cheney. From autumn 1848 the main Dorchester line was owned by the L&SWR, who despite their earlier agreement were again planning a route to Exeter. However, this would branch off their Southampton line at Basingstoke, continuing through Salisbury and Yeovil to reach Exeter. In any case, other events later proved an obstacle to extending the Dorchester line westwards.

The Wilts, Somerset & Weymouth Railway was formed in 1845, with plans for a line southwards from Yeovil, through Dorchester and on to the coast. Progress was slow and the company sold out to the GWR in March 1850. There were changes to the original plan, with the present line finally built in 1856. Services to Weymouth commenced on 20 January 1857. Aware of the GWR's plans, the L&SWR realised that the Weymouth route would pass through Dorchester at right angles to the direction of their line. So, the L&SWR decided that they would run to Weymouth instead, making use of the GWR line. Another problem was that the GWR used broad-gauge track, whereas the L&SWR was standard gauge. It was eventually agreed that the GWR would lay dual-gauge tracks south from Dorchester, with the L&SWR completing a short spur from its station. Initially, L&SWR trains used the original Dorchester station, then reversed to gain the Weymouth line. So, in May 1879 the 'Weymouth Platform' was added at Dorchester to the connecting spur. During the 1890s the L&SWR operated nine trains daily to Weymouth.

Early railway services catered for first- and second-class passengers, with trains often including goods wagons as well. As such, they catered for business previously carried on the local turnpike roads. The running of mixed passenger and goods trains was soon banned as they were deemed too dangerous. When reading of trains with twelve coaches, it must be remembered they were only the size of small goods wagons. Around this time workers began to receive longer holidays and they wanted to take advantage of the new railways. So, the L&SWR provided them with third-class open wagons, not wanting them to mix with the first-class gentry! By the 1870s proper third-class coaches were provided, resulting in an increase in passenger numbers. Goods traffic was also important to the L&SWR, most stations having their own goods yards. By the end of the 1800s trains were being hauled by the likes of Adams and Beattie 2-4-0 or 4-4-0 express locomotives.

A more direct route from London to Weymouth was opened in 1893 (see Chapter 5), resulting in the reduced use of 'Castleman's Corkscrew'. The Broadstone section remained important as part of the S&D route to Bath and also the L&SWR route to Salisbury via West Moors. There were also local services between Bournemouth West, Wimborne and Brockenhurst, as well as goods. Weekdays would see nine passenger trains, with three on Sundays. The original route, now referred to as 'the Old Road', proved useful during busy times. Many holiday passenger trains used it to avoid Bournemouth when travelling to Swanage or Weymouth, along with the Weymouth Boat Train in the early 1960s. Goods traffic also used it to reach Poole, avoiding having to go through Bournemouth. There was now no need for the branch from Ringwood down to Christchurch, so the line closed on 30 September 1935. Services on the 'Corkscrew' continued through the 1940/50s, but by the 1960s passenger numbers were falling. The M7 tanks had gone, replaced by Standard 76000s and 80000s.

The Beeching Report of March 1963 recommended closure of the route, which happened in stages. Stations between Brockenhurst and Broadstone had their passenger services withdrawn from 4 May 1964, although there were still goods trains to Ringwood until August 1967. The Salisbury line from West Moors closed on 4 May 1964; however West Moors still

saw traffic into the RAOC Petroleum Depot until October 1974. Wimborne received limited goods services until it finally closed on 1 May 1977. Three enthusiasts' specials operated that day: a Class 33 and a 4TC set of coaches – something not expected at Wimborne! Broadstone lost its passenger services in March 1966 with the closure of the S&D, with goods passing through to Wimborne until 1977. This marked the end of the majority of 'Castleman's Corkscrew', with the Castleman Trailway now running between Ringwood and Poole.

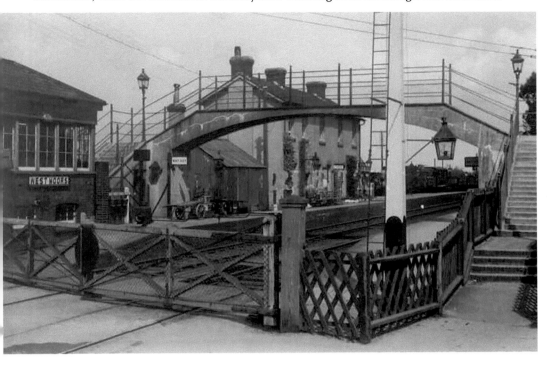

West Moors station, signal box and level crossing around 1900. When the Southampton and Dorchester line was built there was no requirement for a station in what was just rural countryside. This changed in 1867 with the arrival of the Salisbury & Dorset line.

A 1960s view of West Moors for Ferndown with Q Class No. 30541 approaching on a passenger service to Brockenhurst. By now traffic on this section of Castleman's Corkscrew had dwindled as more use was made of road transport.

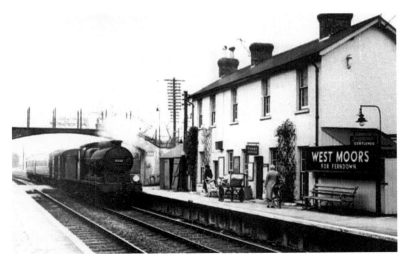

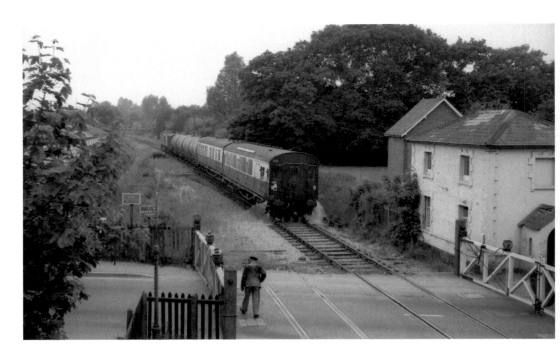

When passenger services were withdrawn in 1964 the line through West Moors was singled, still serving the Army Petroleum Depot. As an 'active' branch it was periodically served by a weed-killing train, seen arriving from Wimborne on 5 June 1971.

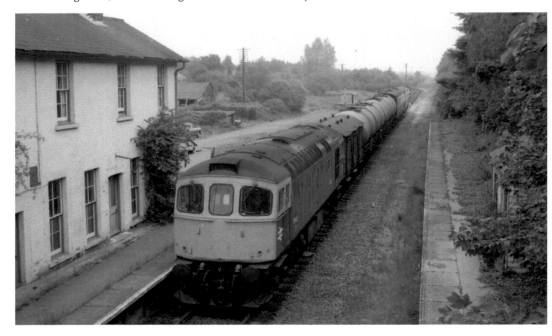

The weed-killing train in the station with Class 33 Crompton No. 6503 in charge. In the background the line curves away into the Petroleum Depot. The track to Ringwood continued straight ahead, later forming the Castleman Trailway.

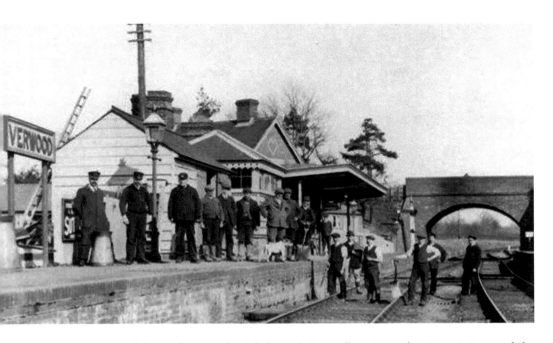

Verwood was one of the stations on the Salisbury & Dorset line situated in Dorset. It served the small village. This posed photo from around 1890 shows the station staff and a large number of gangers poised for action.

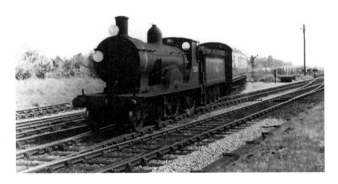

Arriving from the Salisbury line is a T9 with a train bound for Bournemouth West. The line to Ringwood and Brockenhurst is to the right and the line to the army depot branches off the Salisbury line below the first coach.

There were a number of farewell specials during the 1970s, usually hauled by Class 33 Cromptons. No. 6511 is in charge of a LCGB special heading towards West Moors. When the line closed in 1977 the 33s were used on track-recovery trains.

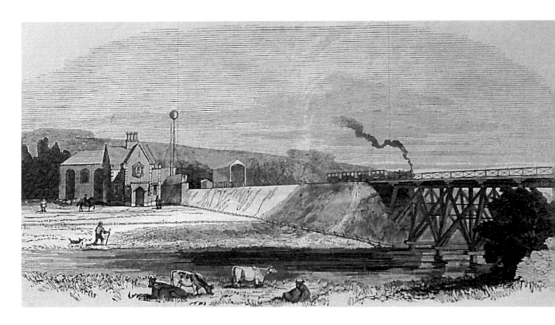

The Illustrated London News covered the opening of the Southampton & Dorchester Railway in June 1847. Here, one of the early trains is depicted crossing the initial wooden viaduct over the River Stour at Wimborne on its way to Poole Junction.

Looking east from Wimborne with one of many special farewell tours approaching. This is an LCGB special that had also visited the Blandford goods line in October 1966 with Standard Class 3 No. 77014 at the head. There are still plenty of tracks remaining.

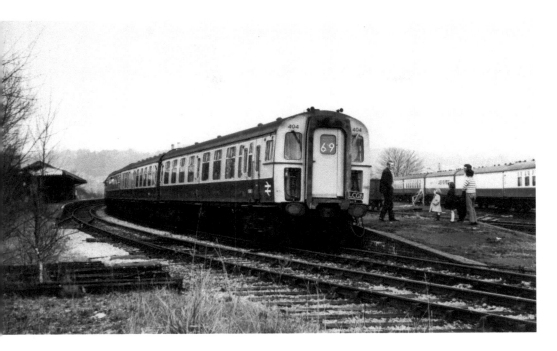

The Corkscrew Shuttle ran on 1 May 1977 to mark the closure of the line to Wimborne. This was hauled by a Class 33 Crompton (at the far end) with two 4TC sets. The goods yard still housed a number of TrainEx coaches awaiting removal.

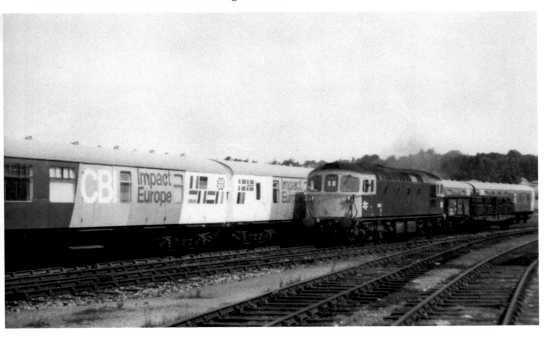

Wimborne's Goods Yard in its final days. For some reason it was chosen to house TrainEx coaches, which were refurbished and repainted for various customers – this set seems to be a prelude to the EU. A Class 33 shunts wagons alongside.

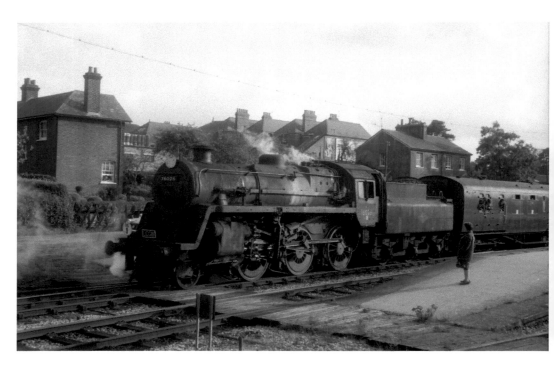

Standard Class 4, No 76026 sets off from Broadstone with an LCGB special to Blandford in October 1966. Passenger services had ended in May 1964, but the track remained for goods traffic to Blandford, Wimborne and West Moors.

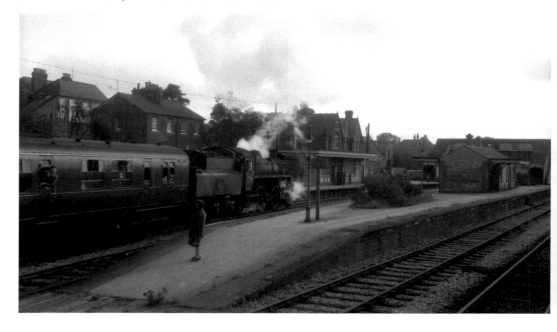

At the other end of the LCGB special was Standard Class 3 No. 77014. A type never seen in Dorset, this one appeared at Bournemouth shed for its last few months of service. Above the station roof the Railway Hotel pub can be seen.

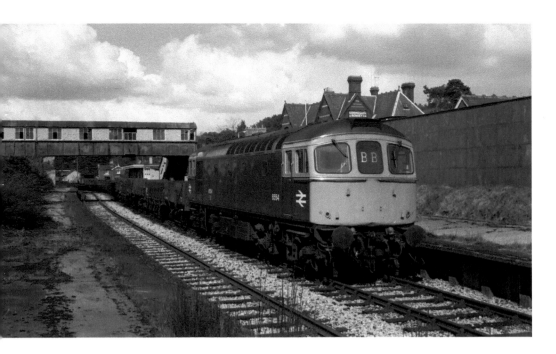

Class 33 Crompton No. 6554 in the Poole-bound platform at Broadstone with a track-recovery train on 19 April 1970. The double track remains, as can be seen, later being reduced to just a single track in order to serve Wimborne Goods Yard.

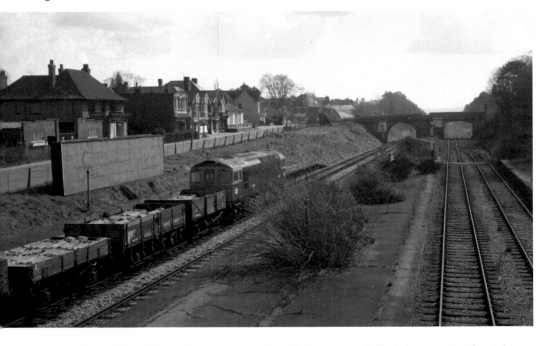

Another view of No. 6554 on its recovery train with its wagons full of sleepers. On the right are the lines to Hamworthy Junction, which latterly had been used as carriage sidings. The platform is overgrown but the track bed is still in good condition.

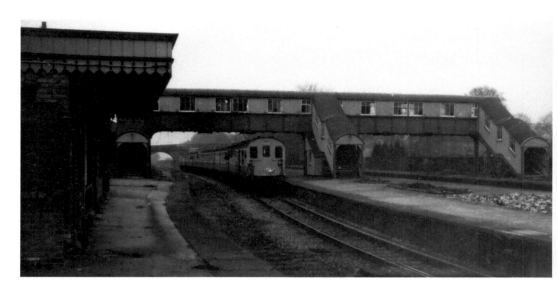

A further farewell special saw Hastings Unit 1019 passing Broadstone on a gloomy 1 January 1972. Only a single track is left and the station buildings have become dilapidated. Nothing remains of the site today; it is covered by a sports centre.

The Railway Hotel in its present guise as the Goods Yard. This must puzzle patrons as there is no sign of a railway and they probably don't know what a goods yard is. However, the main doorway still shows the former Railway Hotel name.

Shunting stock at Hamworthy Junction in the 1960s is an Ivatt Class 2 – one of a number based in the area. Originally the station was an important junction, serving lines to Bournemouth, Weymouth, Broadstone and Hamworthy Goods.

Although parked on the branch from Hamworthy Goods in June 1960, rebuilt West Country No. 34013 *Okehampton* is just waiting for its next duty. Although a goods line, West Countrys might have visited the branch operating rail tours.

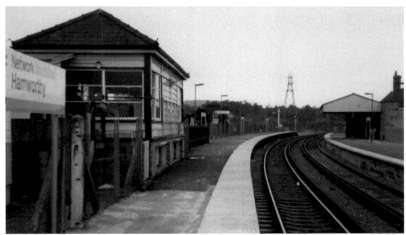

Hamworthy's Down platform canopy was removed in 1972, with passengers now exposed to the elements. Unusually situated on the platform, the large signal box remained in use, with it finally taken out of service in 2014.

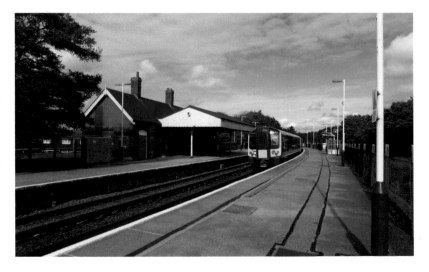

In summer 2017 the franchise for the line passed to South Western Railway, with a Class 444 Desiro passing Hamworthy on a Weymouth train. Buildings remain on the Up platform and a bus stop shelter for passengers is on the Down side.

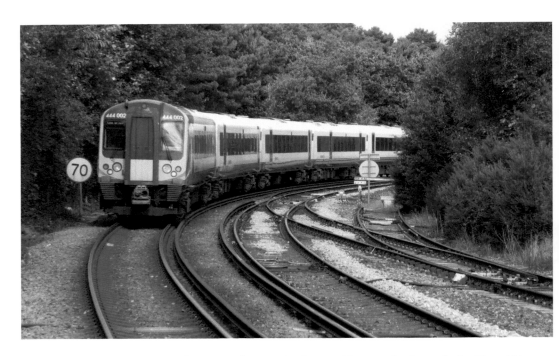

A South West Trains Weymouth to Waterloo service departs Hamworthy formed of a Class 444 Desiro unit. To the right is the line for the Hamworthy Goods branch, which was last used for a scheduled service in spring 2018. Rumours continue that it might reopen.

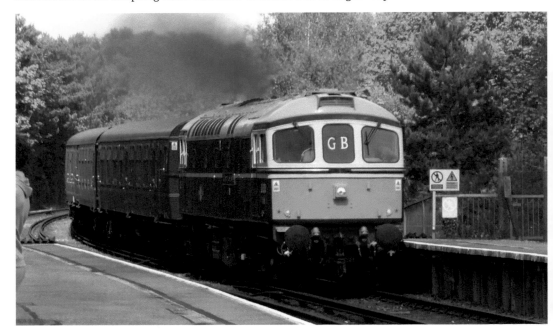

Preserved Class 33 No. 6515 *Lt Jenny Lewis RN* powers through Hamworthy on its way to Swanage to take part in the Diesel Weekend held in May 2018. Jenny Lewis was a Class 33 enthusiast who was killed in a naval helicopter crash.

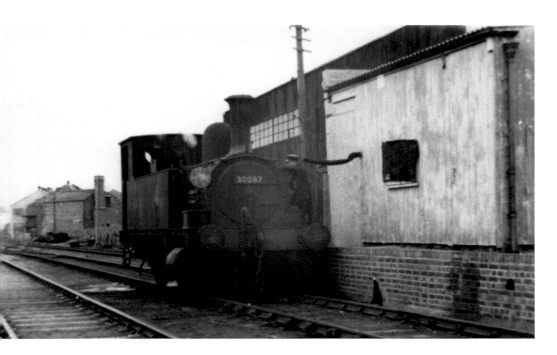

B4 shunter No. 30087 takes on water in the mid-1950s at what was the original Poole station in Hamworthy. The line remained busy for goods serving the main Hamworthy Quay as well as various wharfs, seeing its last service in 2018.

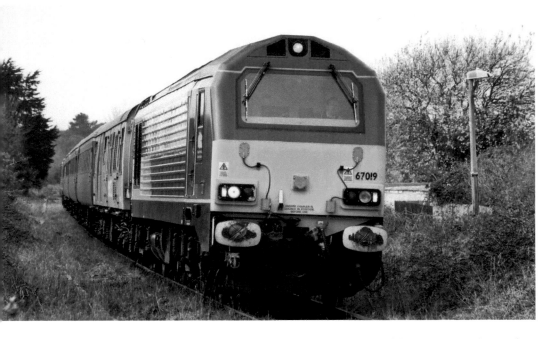

In the 2000s goods trains on the Hamworthy branch were hauled by a variety of main-line locomotives. In this view from 2004, EWS-liveried Class 67 No. 67019 is hauling the Network Rail test train down the branch towards the quay. (SR)

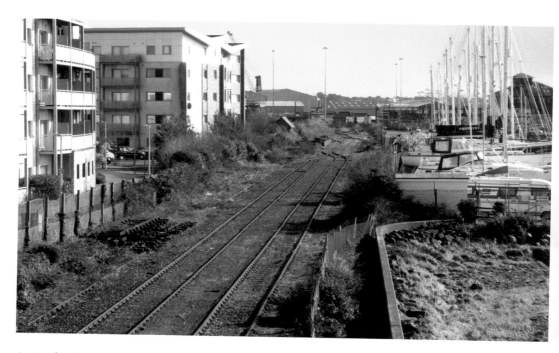

A view looking south with the former station and its pointwork in the distance. The centre track was the main line, while on the right was the run-round loop and on the left a siding. The flats and Poole Yacht Club (right) have appeared since the line's heyday.

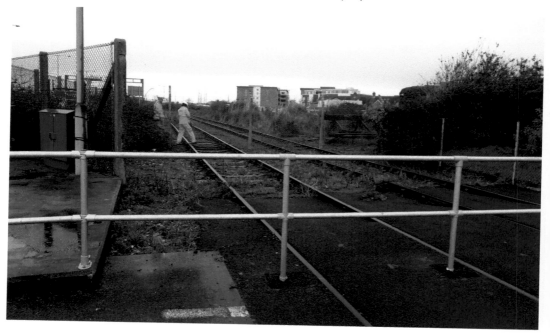

End of the Hamworthy line? In 2019, Poole Harbour Commission erected a barrier over the level crossing marking the boundary with Network Rail. Two engineers check the fence that had previously been installed by Network Rail.

Holton Heath station lies on a straight stretch of the line between Hamworthy and Wareham. Opened in 1916 to serve the long-since closed Royal Navy Cordite Works, it now has only a small bus stop-style shelter on the Up platform.

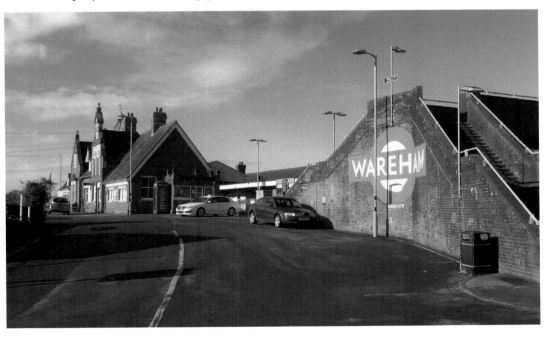

Wareham's second station was opened in 1886 adjacent to the Poole to Wareham road. The adjacent level crossing caused long traffic delays, resulting in a road bridge being built in 1980. A more recent addition is the large name painted on the footbridge wall.

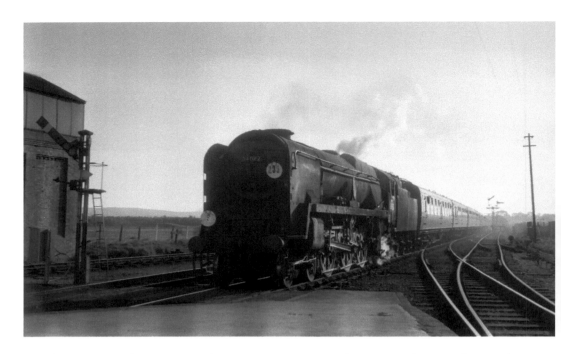

A rather grimy Battle of Britain Class No. 34082 *615 Squadron* approaches Wareham with a stopping train from Weymouth in the mid-1960s. Swanage trains used the platform to the right for their arrivals, while the far-left platform was for departures.

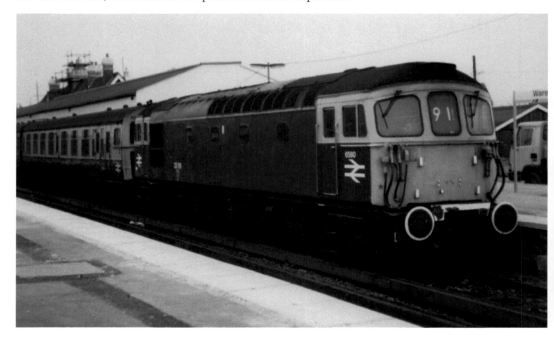

Following the end of steam, services through Wareham were operated by Cromptons plus a 4TC set of coaches. Here No. 33119 paused on its way to Weymouth, the Crompton also carrying its pre-TOPS number of 6580.

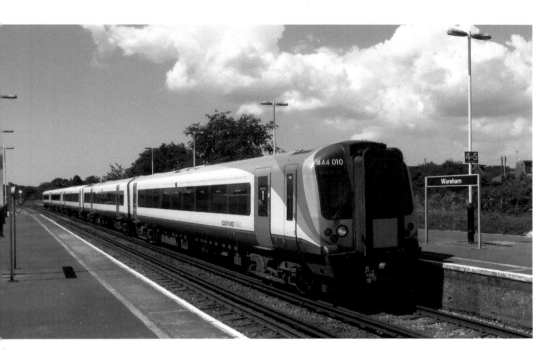

A South West Trains Class 444 Desiro at Wareham on a Waterloo-bound train in summer 2014, with two trains an hour in each direction. In the near future the Swanage Railway intends to run services to Wareham to connect with main line trains.

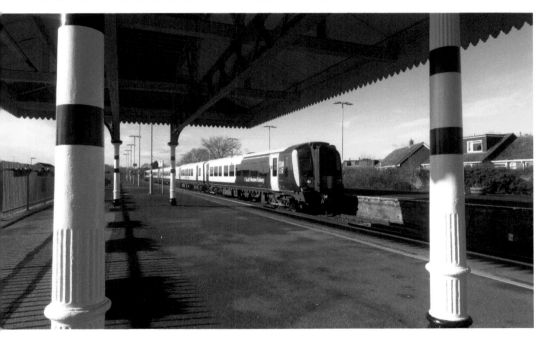

Framed by the Down platform canopy, a SWR Desiro arrives with a service from Weymouth in February 2022. At the time staff shortages due to Covid-19 resulted in services reduced to just an hourly shuttle between Bournemouth and Weymouth.

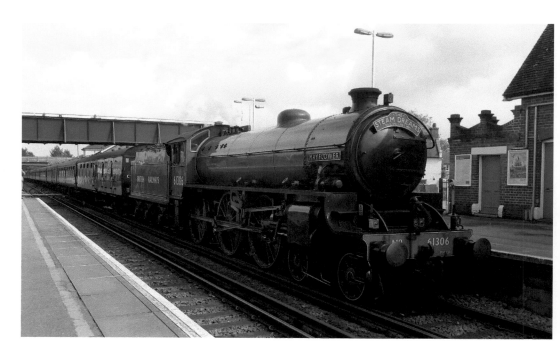

During summer months the main line sees a number of steam specials. Here, Class B1 No. 61306 *Mayflower* drifts into Wareham in September 2019 on its way to Swanage. It is about to pick up extra crew who know the Swanage route.

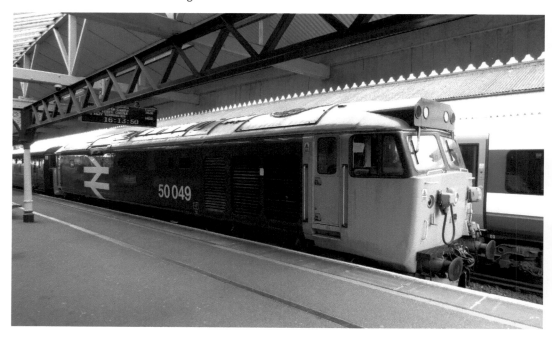

The Swanage Railway holds frequent diesel weekends. During May 2018 a number of specials operated over the length of the line into Wareham. Here is Class 50 No. 50049 *Defiance* with the station's destination indicator showing 'Corfe Castle'.

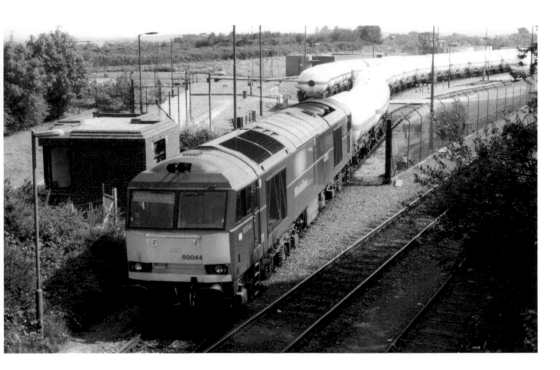

On the Swanage branch there were sidings at Furzebrook, originally for clay traffic. New ones were added in the 1960s for oil traffic and then LPG. Class 60 No. 60044 *Ailse Craig* in Mainline Freight colours departs for Avonmouth on 28 August 1996.

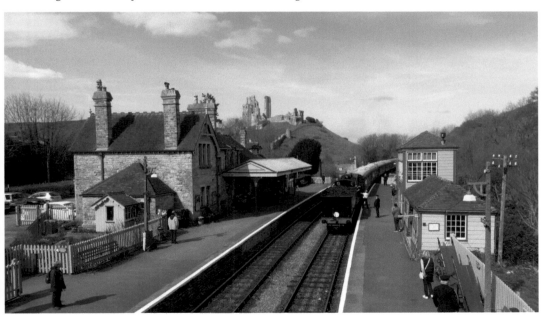

Corfe Castle station with the well-known castle ruins in the background. It's hard to imagine that the track had been torn up in the 1970s; luckily the main station building remained. Class T9 No. 30120 is approaching with a train for Swanage in March 2019.

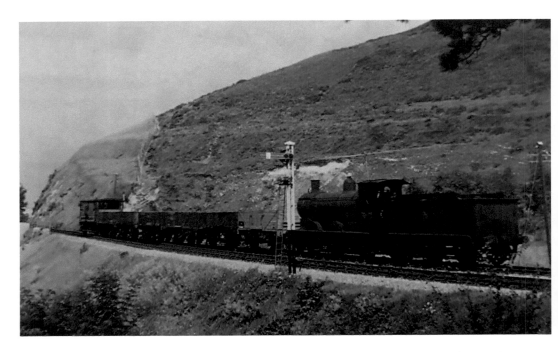

Local goods traffic in the Dorset area was in the hands of Drummond Class 700s in the 1940/50s. Here No. 30695 passes East Hill at Corfe Castle with an all-stations goods train bound for Swanage. Tender first working was normal on the branch.

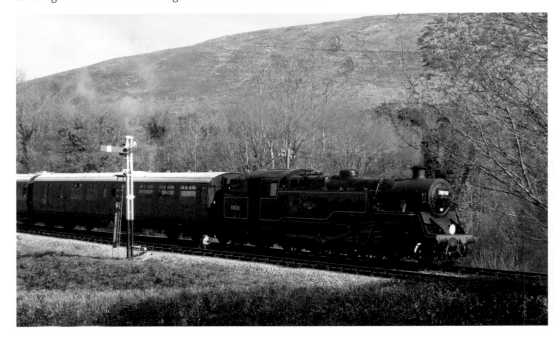

Seen in the same location as No. 30695, Swanage-based Standard Class 4 No. 80104 masquerades as No. 80126 in March 2019. The real No. 80126 was never seen in Dorset as it was a Scottish-based locomotive.

Approaching the A351 road bridge south of Corfe Castle is Standard Class 4 No. 80104 with a train from Swanage in the 2010s. The area around the bridge became a favourite spot for photographers in preservation days.

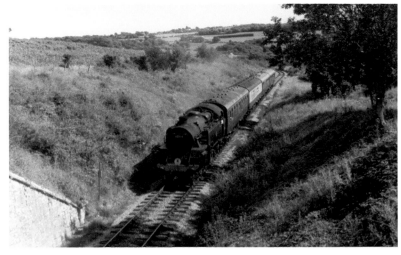

Battle of Britain Class No. 34070 *Manston* approaches the A351 bridge from the other direction with a demonstration goods train during one of Swanage Railway's Steam Weekends. One wonders if the train was ever this clean in British Railway days. (SR)

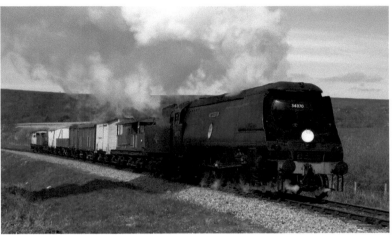

Approaching Corfe Castle station on 26 March 2019 is A3 *Flying Scotsman.* The locomotive operated a number of services over the Swanage Railway during the spring, with large crowds descending on the Purbecks to witness its visit.

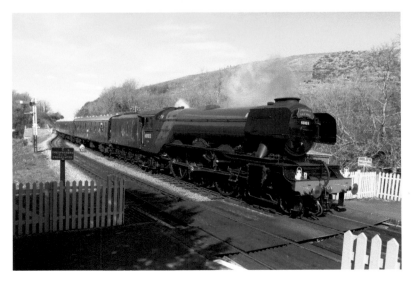

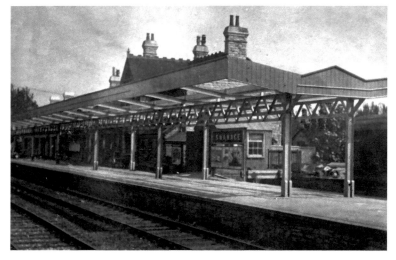

A rather deserted-looking Swanage station in the 1920s. The town was a popular destination for holidaymakers, with through trains from Waterloo. Original plans were for an extension to Swanage Pier to meet the existing tramway, but this was never built.

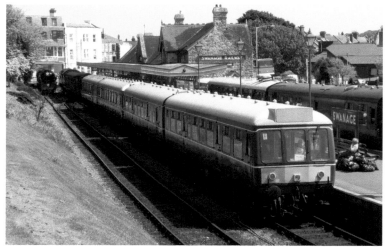

In preservation days there were plans for regular services by diesel units. Unfortunately, this took much longer to achieve than originally hoped. A former Western Region DMU is seen in spring 2009, with the station looking busier than in earlier views.

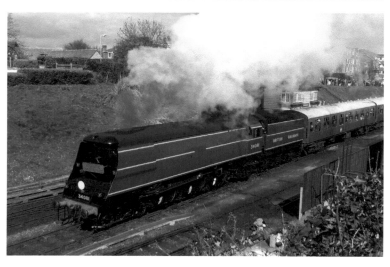

Battle of Britain Class No. 34081 makes an impressive departure from Swanage in April 2017 during a Bulleid Steam Weekend. On this occasion the Swanage Railway managed to operate five Bulleid locomotives on intensive services.

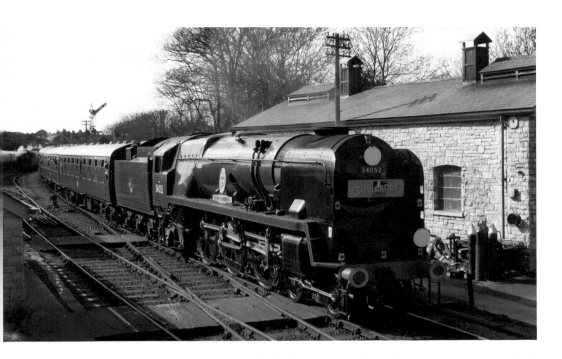

During the April 2017 Steam Weekend rebuilt West County No. 34046, appearing as Battle of Britain No. 34052 *Lord Dowding*, passes Swanage's small loco shed. On such occasions it is hard to imagine that the line had disappeared in 1971, being rebuilt by the team of volunteers.

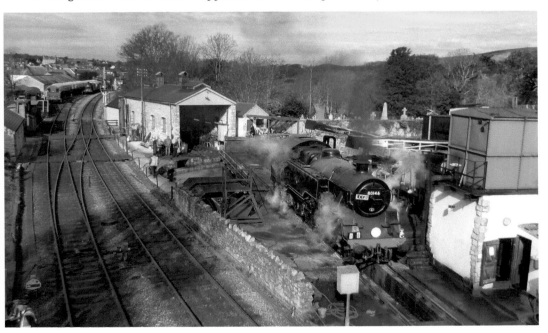

Swanage's loco shed and turntable. The shed could accommodate an M7 tank, but the turntable proved too small for larger locos that appeared in the 1930s. Standard Class 4 No. 80104 was leading a double life during 2017 by appearing as No. 80146.

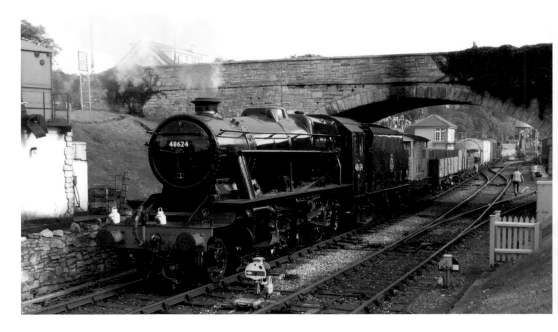

Visiting Stanier 8F No. 48624 departs with a goods train during the 2016 Autumn Steam Gala. Although an LMS loco, it was built by Southern during the Second World War for the LMS. It almost ended its days in the Barry scrap yard, but was saved for preservation.

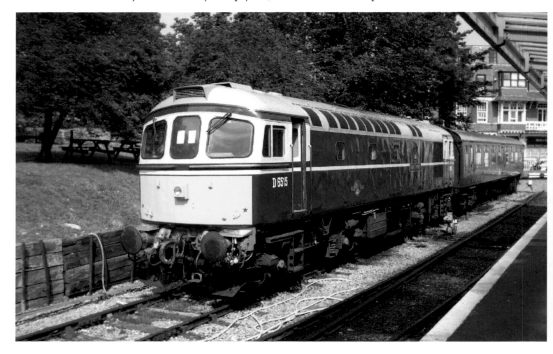

Stabled at the buffer stops, Class 33 D6515 shows the closeness of Swanage station to the town's shops. In this summer 2007 view it carries the name *Stan Symes*, but after overhaul in 2014 it reappeared as *Lt Jenny Lewis RN*.

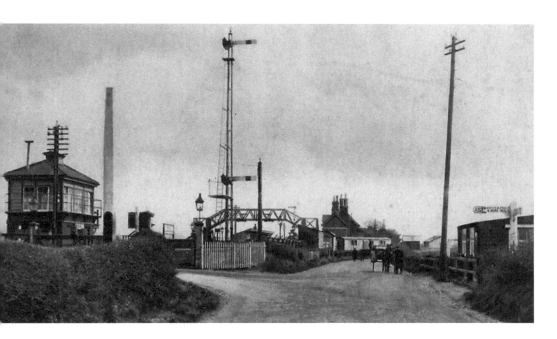

An early view of Wool station from the Dorchester Road. The road to Lulworth lies straight ahead, while Wareham is across the level crossing. A Weymouth-bound train can just be seen in the station, while in the approach area is a surplus coach.

A view from a similar location, but this time it's July 2020. A Class 444 Desiro is arriving from Dorchester and about to reach the level crossing. During summer months its operation causes long delays to local road users.

The original station buildings on Wool's Down platform were demolished in 1969 and replaced by this 'stylish prefab'. Although easy to maintain, it does nothing to enhance arriving passengers' thoughts of the Purbecks and the Jurassic Coast.

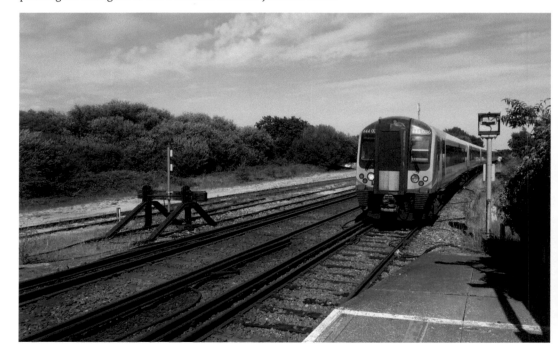

A Weymouth-bound Class 444 Desiro No. 444036 arrives at Wool in July 2020. Two sidings remain on the Up side of the line, having been used for many years for sand traffic and transporting army vehicles from the nearby Bovington Military Camp.

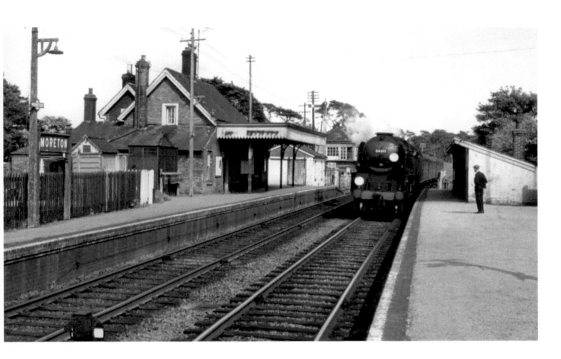

Moreton station serves the small villages of Crossways and Moreton. The original station buildings on the Up side can be seen in this view of rebuilt West Country No. 34021 *Dartmoor* arriving on a Weymouth-bound train in the 1960s.

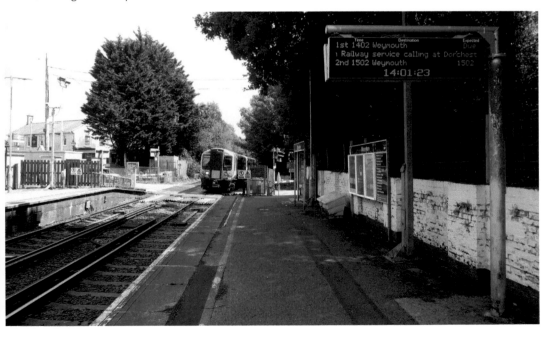

Like Wool, Moreton's original station buildings were demolished, this time being replaced by two bus stop shelters. Desiro No. 444009 reaches the station's level crossing with a Weymouth-bound train in July 2020.

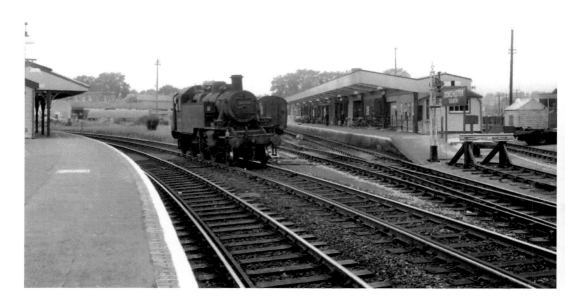

Dorchester South in the 1960s with an Ivatt 2MT arriving. The connection to the GWR Weymouth line curves away to the left. On the right is the original station, with Waterloo-bound trains having to reverse back into it on arrival from Weymouth.

Arrival of a double-headed Waterloo-bound train in the summer of 1964 via the sharp curve from the GWR. The locos were a rebuilt West Country and a Standard Class 5. Alongside the Down platform is a siding used by local coal merchants. This site is now covered by housing.

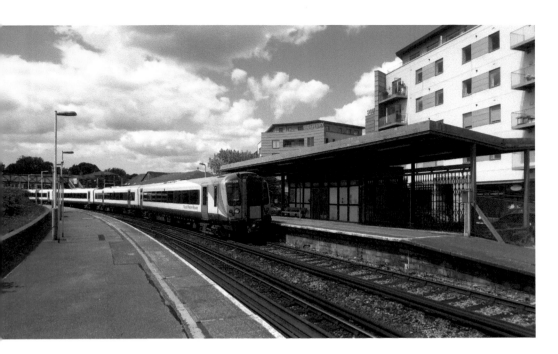

Viewed from the Weymouth-bound platform seen earlier, the whole area has been transformed. The former Eldridge Pope brewery has been replaced by a new housing and shopping complex to the right. New station buildings were incorporated into the development in 1987.

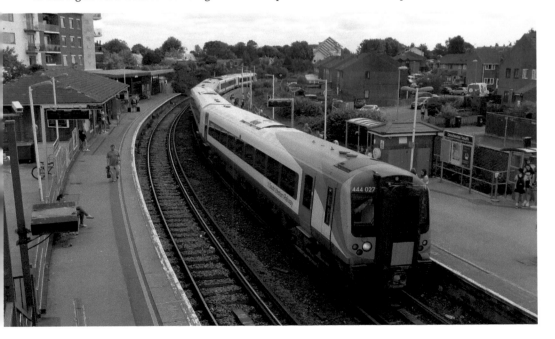

Desiro No. 444027 collects passengers for a Weymouth-bound train at Dorchester South in July 2020. The goods shed was at the far end of the Up platform and the loco shed was to the right. Again, this is now covered with housing.

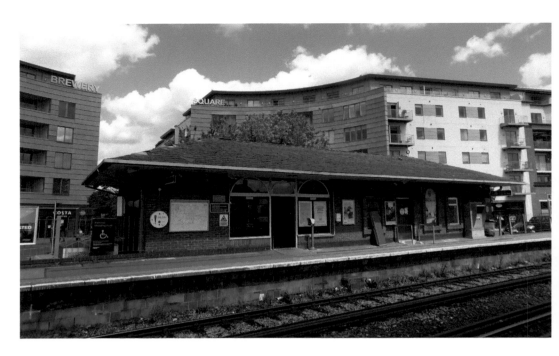

Dorchester South's Up platform and station buildings, which were brought into use in autumn 1987. The site of the original Up platform now lies beneath the Brewery Square development of the 2010s.

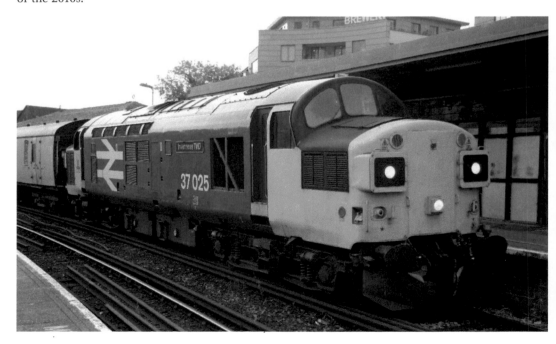

An unusual visitor to Dorchester South in June 2020 was the Network Rail test train, hauled by preserved ScotRail-coloured Class 37 No. 37025 *Inverness TMD*. The train had worked down to Weymouth testing the stability of the track. It is seen here on its return. (SR)

2. Great Western into Dorset

The Wilts, Somerset & Weymouth Railway was formed in July 1844 in association with the GWR. Plans for a line to the south coast were drawn up in June 1845, but there were delays in deciding which route would be taken. This resulted in the Wilts, Somerset & Weymouth selling out to the GWR on 14 March 1850. Eventually, Brunel's broad-gauge route was settled, coming into Dorset from the north at Yeovil (Pen Mill), then proceeding south through Maiden Newton and Dorchester to its destination. An impressive station with an adjacent large goods shed was built close to the sea front. The section from Yeovil to Dorchester was single track, then double to Weymouth. On construction, agreement was reached with the L&SWR for it to have running rights over the line, with services commencing on 20 January 1857. Weymouth was already a popular seaside resort, having come into fashion around 1770. It gained further fame as George III took his summer holiday in the town in the early 1800s. The town was also a busy harbour, serving cross-Channel packets, and in the 1920s was advertised by the GWR as 'the Naples of England'.

Traversing the rural Dorset countryside, the route's only major station was at Dorchester – the county town. However, the GWR provided many villages with stations or halts. Yetminster, Evershot, Maiden Newton and Grimstone & Frampton were all opened for the initial services, but others waited until the 1930s – Thornford Bridge Halt, Chetnole Halt, Cattistock Halt and the grand-sounding Bradford Peverell & Stratton Halt. South of Dorchester there was Upway on the northern suburbs of Weymouth. All of Monkton & Came Halt, Upway Wishing Well Halt and Radipole Halt came into use on 1 June 1905. Connected by newly built steam railmotors, these halts were opened to counter a new omnibus service operating between Dorchester and Weymouth. The halts were provided with pagoda-shaped waiting shelters – typical of many GWR halts. Frampton had a crises of identity as it was opened in January 1857 as Frampton, then the GWR renamed it Grimstone in July 1857 and finally Grimstone & Frampton in July 1858. It was situated in the hamlet of Grimstone, but was intended to serve the nearby village of Frampton.

The GWR also planned an extension to Portland, but this was soon dropped. The Weymouth & Portland Railway was formed in June 1862 to build a mixed-gauge line, which would be jointly operated by the GWR and L&SWR. Completed in April 1864, its opening was delayed until October 1865 due to arguments over which section of Weymouth station should be used for the services. The Portland branch diverged from the main line just north of Weymouth station and initially trains had to reverse out of the station before accessing the branch. This changed in 1908 when a station was built on the branch at Melcombe Regis – it was almost adjacent to the main Weymouth station. A steeply inclined extension from Portland south to Easton opened to goods in October 1900, with passenger services having to wait until September 1902. A number of connections and sidings were provided at Portland for the extensive Royal Navy base.

Another branch was the Weymouth Harbour Tramway, which was built to serve the Channel Island paddle steamer packets arriving at Weymouth Quay. Opened in October 1865, wagons were initially horse-drawn until steam traction took over in 1890. Shipping services were operated by the Weymouth & Channel Islands Steamship Company until 1 July 1889 when the Great Western took over. The tramway was slightly extended to meet the new berth of the Great Western Channel Islands steamers, with the islands increasing in popularity as a holiday destination. The GWR service from Paddington to the

Channel Islands was in competition with the L&SWR service provided from Waterloo via Southampton Docks to the Channel Islands – both companies introduced new steamers. The GWR claimed a shorter sea crossing from Weymouth, although the train journey was much longer. The GWR operated the sea routes to Guernsey and Jersey with 'Express Royal Mail Twin-screw steamers'. After arrival of the boat train the steamer would leave Weymouth at 2:15, arriving in Jersey at 8:00. In later years the train service was named the 'Channel Islands Boat Express' and some days required four services to cope with all the passengers.

Goods traffic expanded with fresh produce being shipped from the islands, including potatoes, tomatoes and other vegetables for London markets. Additional sidings were provided at Weymouth to cater for all the wagons waiting to make their way down the tramway to collect produce. Boat trains and other well-laden services from Weymouth faced a steep climb as they headed north to Dorchester, the line reaching a climax at Bincombe. This resulted in trains either being double-headed or having a banking engine at the rear. The banking engine would drop off the rear of the train after clearing Bincombe Tunnel and cross lines to make its way back to Weymouth.

In 1857, the Bridport Railway built a branch line from the town to the main line at Maiden Newton, financed by local businessmen. Built as broad gauge, it was leased to the GWR, opening on 12 November 1857. It was extended to the coast at West Bay on 31 March 1884 in anticipation of the area expanding as a holiday destination. At Maiden Newton the branch had its own bay platform, as well as being served by trains from Weymouth. The branch was taken over by the GWR in July 1901, but the anticipated holidaymakers failed to arrive.

A branch to Abbotsbury was proposed in 1873, connecting with the main line near Upway. The Abbotsbury Railway was eventually formed in August 1877, with construction commencing in April 1879. The main reason for the branch was the discovery of mineral and iron ore deposits around the village, with thoughts of the area being turned into a vast industrial area. Construction of the standard-gauge line was protracted, one reason being that land had to be acquired from many different landowners. By 1884 work had come to a halt and refinancing was necessary to get it completed the following year. It was soon realised that the iron ore was of poor quality and limited quantity – there would be no industrial revolution. Services finally commenced on 9 November 1885 and were worked by the GWR. A replacement station at Upway Junction came into use on 19 April 1886, which made operations easier with the branch having its own platform. The Abbotsbury Railway realised operations were financially unviable and sold out to the GWR on 1 August 1896. Following the Second World War there was little traffic and the branch closed on 29 November 1952.

Services on both branches were frequently operated by GWR steam railmotors from 1905, then replaced by single-coach diesel railcars from 1936. Tiny Class 517 tank locomotives, plus one coach, were also used, later being replaced by Class 1400 tanks. Then it was mainly tank locomotives until steam was withdrawn in 1965.

As mentioned, the line from Dorchester to Weymouth was dual gauge. However, the GWR realised its disadvantage as every other railway company built their lines to standard gauge. Reluctantly, they converted their lines to standard gauge during June 1874, along with building a fleet of new locomotives and coaches. The Weymouth line saw its final broad-gauge service on 18 June. Then, in 1885, the line between Yeovil and Dorchester was doubled. The GWR initially had a small locomotive shed close to Weymouth station, but increased traffic saw a much larger one opened to the north of the station in 1885. The L&SWR also had a small locomotive shed adjacent to the station, which closed in 1939 with the GWR allowing them access to their shed.

Following nationalisation in 1948 the GWR became the Western Region of the new British Railways. The GWR station at Dorchester became Dorchester West in 1949, with the Southern one becoming Dorchester South. Other changes included the transfer of the Yeovil to Weymouth line to the Southern Region in April 1950, although services were still operated by Western locomotives (e.g. Counties, Halls and Granges). The Portland branch closed to passengers on 3 March 1952, although goods remained until 1965, mainly to serve the naval base. In a turnaround, the line between Yeovil and Weymouth was transferred back to the Western Region in 1962. However, there was less Western steam traction as diesels were taking over – Class 31s, Hymeks and Warships. Weymouth lost its allocation of Western passenger locomotives, just retaining some tank locomotives for working the Quay Tramway and empty stock movements. However, Southern main-line steam continued to serve Weymouth for a few more years. The Beeching Plan had its effect on the line, with many of the stations and halts closed in October 1966. The line between Yeovil and Dorchester West was singled during 1967/68, with a passing loop retained at Maiden Newton. This had the effect of making the few remaining halts look even more isolated than before. Goods traffic from Weymouth now took the Southern route at Dorchester, not the Western one. However, Weymouth goods shed and yard only lasted until 1972 as it was no longer economical for the railway to carry local goods traffic. Class 101 diesel units were used for many passenger services, replaced by Class 117 three-coach units in 1983, then Class 150 two-coach units. The Bridport branch had been threatened with closure under the Beeching Plan but managed to survive until 5 May 1975, operated by Class 121 single-coach diesel units. The branch had probably ensured the survival of Maiden Newton station during the 1966 cuts.

The Weymouth Quay Tramway remained busy with boat trains during the 1950 and 1960s. However, the former GWR route lost the boat trains in 1960 when the London terminus was switched to Waterloo, the service now operated by Southern locomotives and coaches. The former GWR ferries were operated by British Railways before being renamed Sealink in 1968. Trains over the tramway continued to be operated by GWR Pannier Tanks and, when they were withdrawn, diesel shunters. From the 1980s the trains were normally hauled by Class 33 diesels. The once important goods traffic was withdrawn in February 1972, but passenger operations continued. Goods were now carried in containers which Weymouth could not handle, so it switched to Southampton. Then in September 1987 Sealink withdrew its Channel Island services, resulting in the end of the connecting boat trains. However, the tramway was not officially closed and saw a number of rail tours until May 1999, with the track finally lifted in autumn 2020.

From December 1988 services to Weymouth were operated by First Great Western. Summer Saturdays saw locomotive-hauled services from Bristol Temple Meads to Weymouth, with Class 37, 47 or 67 diesels. In September 2010, the locomotives were replaced by high-speed train sets.

From September 2015, First Great Western was rebranded as Great Western Railway – the line returning to its roots. Known as the 'Heart of Wessex line', services were initially operated by Class 150 and 158 diesel units, replaced by Class 166 Networker Turbo three-coach units from spring 2018. By then the remaining halts on the line had been classified as request stops. The route normally saw seven return services a day from Bristol Temple Meads. Much of the line looked neglected by the late 2010s, with rotting wooden sleepers and weeds growing between the tracks. Major engineering works were undertaken on parts of the line in autumn 2021, indicating that it still has a future.

The GWR line into Dorset arrived from Yeovil in 1856, with services to Weymouth commencing in January 1857. Although in Somerset, here we see Class 158 Express Sprinter No. 158829 having arrived at Yeovil Penn Mill from Weymouth on 8 October 1994.

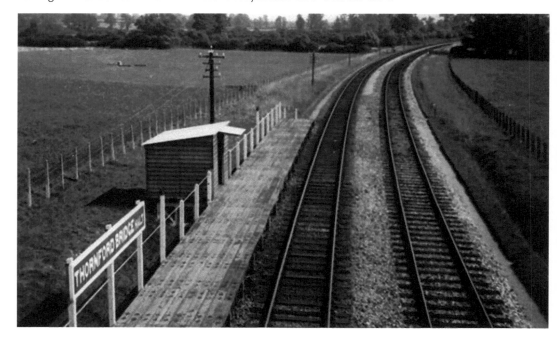

Traversing the rural Dorset countryside, the GWR provided halts or small stations. Typical is Thornford Bridge Halt, situated to the west of the village. Often the Up platform would be to the north of the adjacent road bridge, with the Down platform to the south.

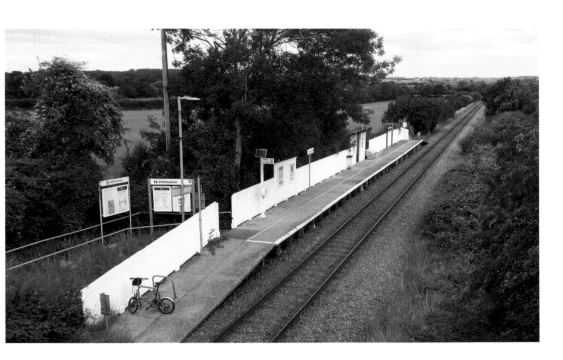

When the former GWR line was singled in 1968, some of the halts surprisingly remained despite low passenger numbers. Only one platform plus a small shelter remained, making the halts seem very remote, such as Chetnole, seen in July 2020.

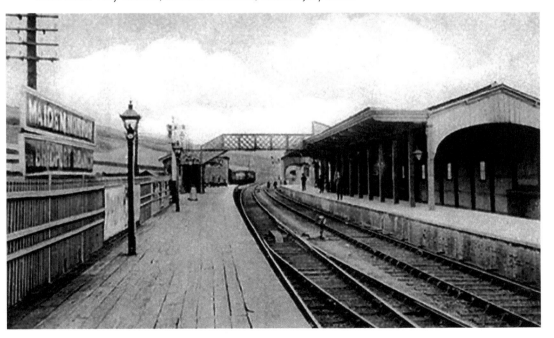

The village of Maiden Newton was provided with a fairly substantial station. Business increased from December 1857 with the opening of the Bridport branch, which had its own covered bay platform seen to the right.

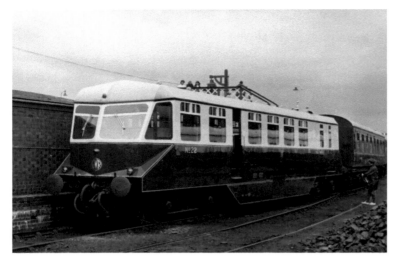

Services on the Bridport branch were operated by steam railcars in the early 1900s, being replaced in the 1930s by GWR diesel railcars of the type seen here. One remained based at Weymouth until the early 1960s to cover the services.

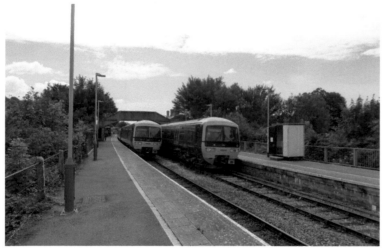

With the singling of the main route in 1968 Maiden Newton remained a passing place. Here north- and southbound GWR Class 166 Networker Turbos pause at the station as their drivers await authorisation to proceed.

Networker Turbo No. 166218 departs Maiden Newton northwards in July 2020, regaining the single line en route to Yeovil. The Bridport branch was to the left of the main line separating away under the road bridge in the background.

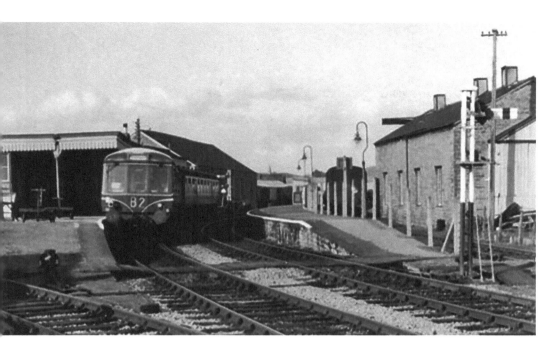

A substantial station was built by the Bridport Railway at Bridport in 1857 in anticipation of future business, but traffic did not increase as hoped. In the 1970s it was frequently served by a single-coach railcar, seen here with an additional coach added.

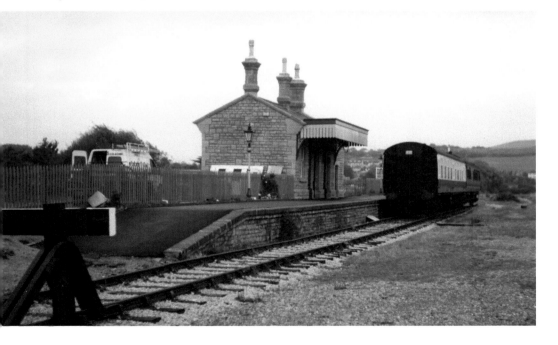

West Bay was built in anticipation of holiday traffic. This did not occur, so passenger services ceased in 1930. The station building remained and was restored in 1995 as a café with the addition of a couple of coaches on a short length of track.

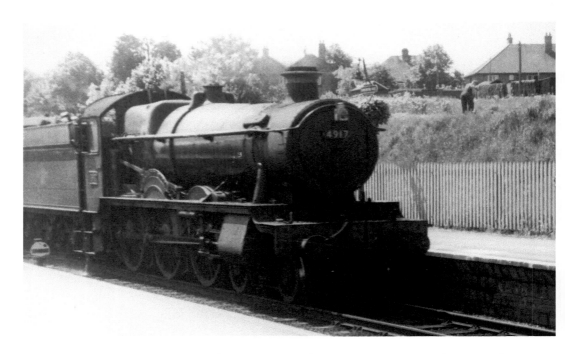

Hall Class No. 4917 *Crosswood Hall* arrives at Dorchester West in 1957 with a train from Weymouth. Hall and Granges classes were frequently used on passenger services. The land in the background is in use as allotments.

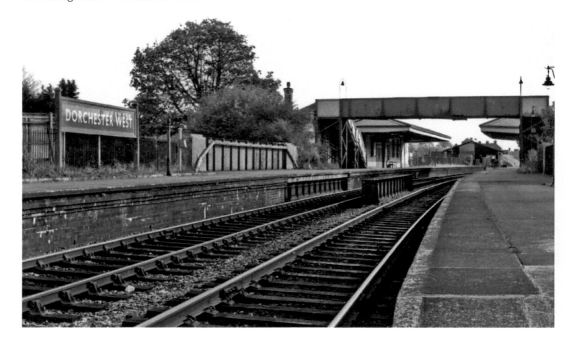

A view of the station looking south in the late 1950s. At the time it was part of the Southern Region and they have installed a Southern-style station name board. Beyond the station is the goods shed; this area was later redeveloped as a retail park.

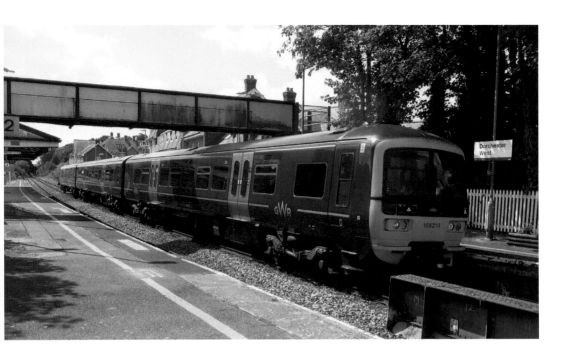

GWR livery Networker Turbo No. 166210 about to depart to Gloucester in July 2020. The all-stations/halts service took just over three hours to travel from Weymouth to Gloucester, with seven return services each weekday in 2020.

Although the line was operated by GWR in 2020, unit 166221 is still in its earlier First Great Western livery. The Down side buildings remain, but not for railway use. The allotment area behind the Up platform is now covered by housing.

The station building was vacated by the railway many years ago and has seen various uses in recent years. The entrance to the station is to the right of the building, leading to automatic ticket machines on the platform.

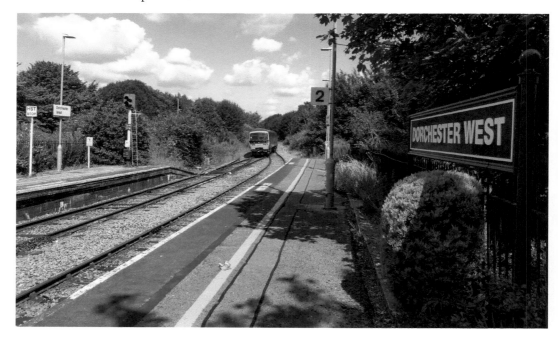

A Class 166 Networker Turbo regains the single track as it heads northwards out of Dorchester West. On the Up platform is a HST stop indicator, whilst on the Down platform is a GWR-style station name board.

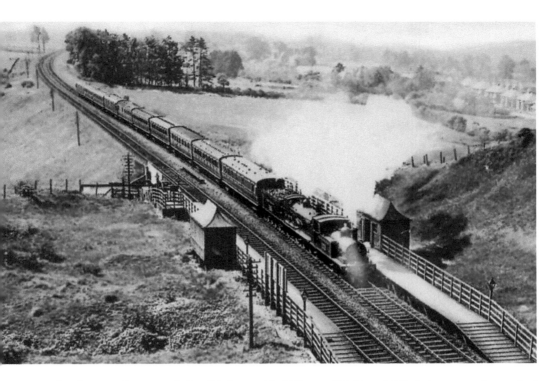

South of Bincombe Tunnel the GWR provided Upway Wishing Well Halt – note the typical GWR pagoda-style shelters. This 1939 view of a Southern Region train shows a tank engine assisting on the climb out of Weymouth.

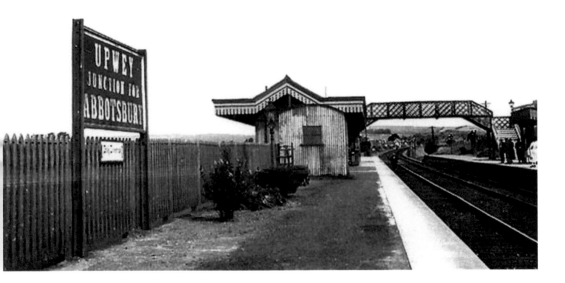

As the name board says, Upway was the junction for the short branch to Abbotsbury. The branch had its own platform to the left of the main station buildings. Long gone, the space now serves as the station car park.

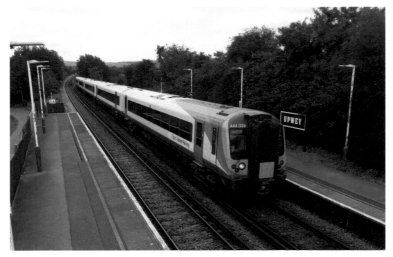

South Western Railway Class 444 Desiro No. 444026 arrives at Upway from Dorchester in July 2020. There are more South Western services than Great Western at the station, which has reverted to its Upway name but with a GWR-style name board.

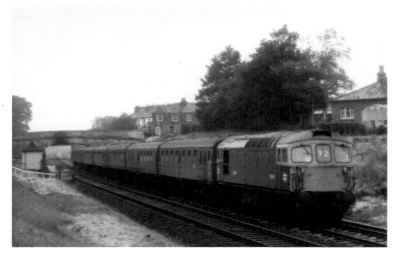

The GWR built Radipole Halt to serve the expanding northern area of Weymouth – again provided with pagoda-style shelters. Class 33 Crompton D6536 passes in 1964 with a semi-fast Waterloo to Weymouth train.

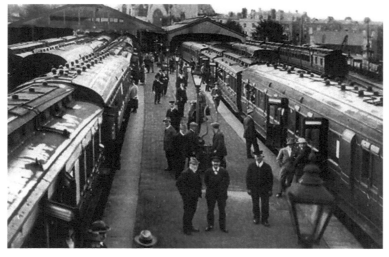

A busy scene at Weymouth station in summer 1924. Great Western trains normally departed from the platform to the left, with Southern departures to the right. There were plenty of sidings for stabling coaching stock.

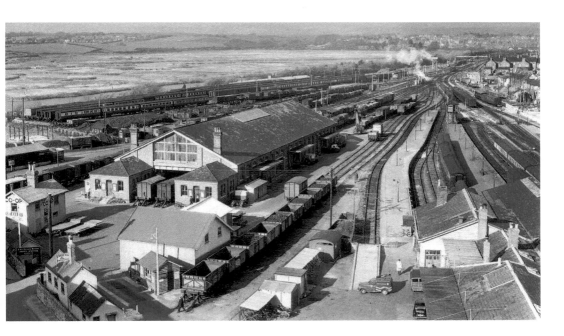

The railway occupied a vast area at Weymouth. The GWR station is to the right and the large building in the centre is the goods depot. A large number of carriage sidings are in use alongside Radipole Lake in this 1960 view.

Rebuilt Merchant Navy No. 35014 *Nederland Line* sets off for Waterloo in May 1964. Again, this shows the large number of tracks provided at Weymouth. A Hymec waits in the far-left platform, while to the right a DMU waits on a local service.

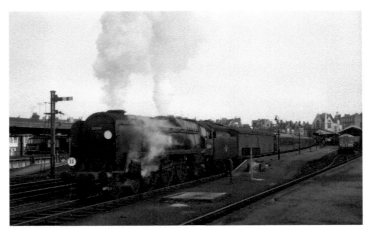

Climbing the bank encountered after leaving Weymouth in May 1964 is rebuilt Merchant Navy No. 35030 *Elder Dempster Lines* bound for Waterloo. It will shortly pass the locomotive shed on the far side of the main line.

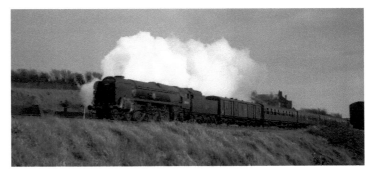

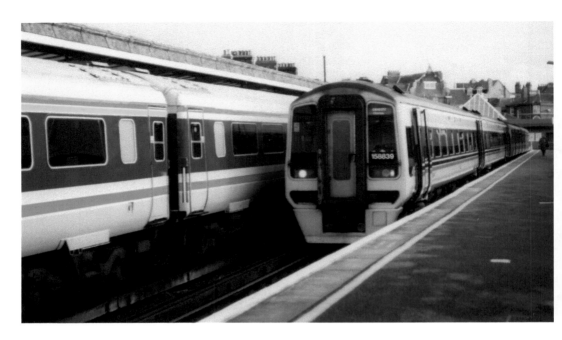

In the 1990s operations at Weymouth were from a much smaller station than that originally provided by the GWR. A Class 158 Express Sprinter prepares to depart to Cardiff on 18 December 1994, while to its left is a Class 442 Wessex Electric.

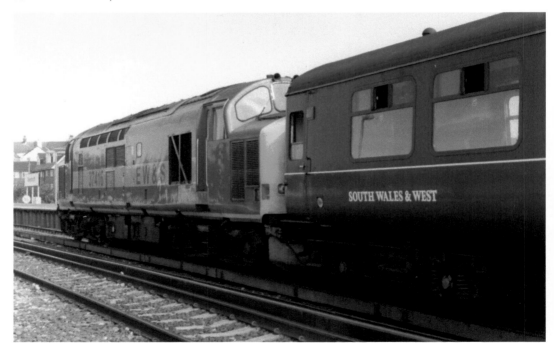

Weymouth continued to see loco-hauled trains on the former Western route in the 1990s. Here EWS-liveried Class 37 No. 37416 awaits departure on 28 August 1996, partnered with South Wales & West coaching stock.

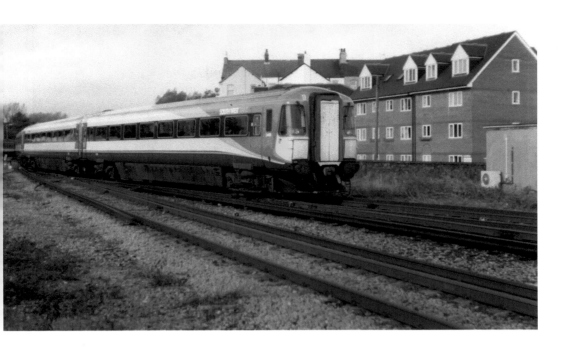

Crossing the tracks as it departs for Waterloo is a South West Trains Class 442 Wessex Electric. These provided Weymouth passengers with their fastest ever service to the capital. The 442s were replaced by Class 444 Desiros early in 2007.

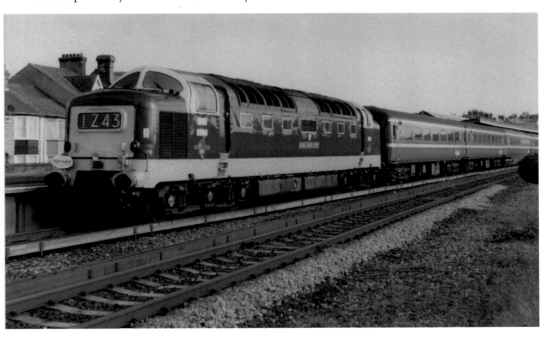

A loco not normally seen at Weymouth. Preserved Deltic D9000 *Royal Scots Grey* awaits the return leg of the Sand Stormer tour from Waterloo on 23 October 1999. Its routing was via the former GWR line to Yeovil, ending at London Victoria.

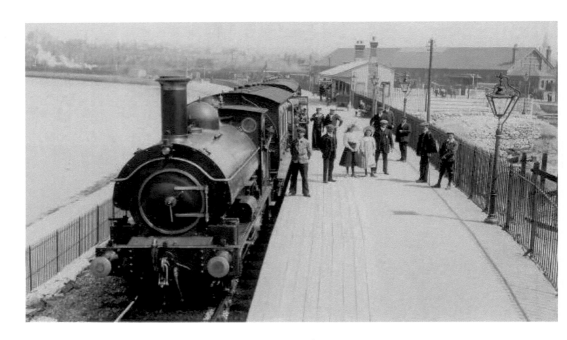

Passengers pose for the camera before departing from the newly opened Melcombe Regis station. The Portland branch train is hauled by a GWR saddle tank – the type also being used on the Weymouth Tramway.

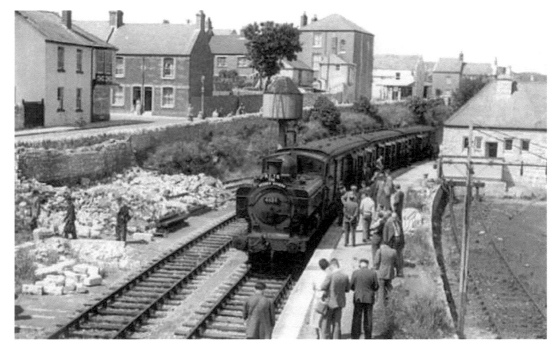

A RCTS rail tour at Easton in summer 1956 – the southern end of the Portland line. Although closed to passengers in March 1952, the line remained opened for goods and stone traffic. Pannier Tank No. 4524 will run round its train for the return to Weymouth.

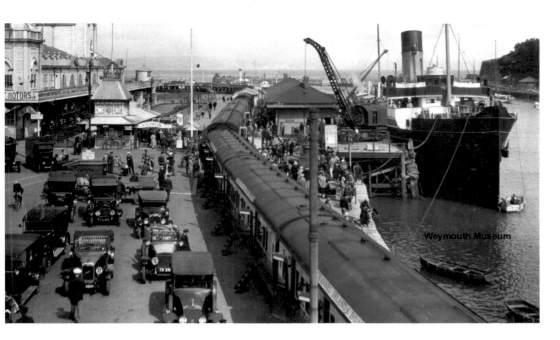

A view of the Great Western berth at Weymouth Quay in the 1920s. Passengers have disembarked from the Boat Express from Paddington and make their way to the Channel Islands steamer. Others have arrived by luxury cars. (Weymouth Museum)

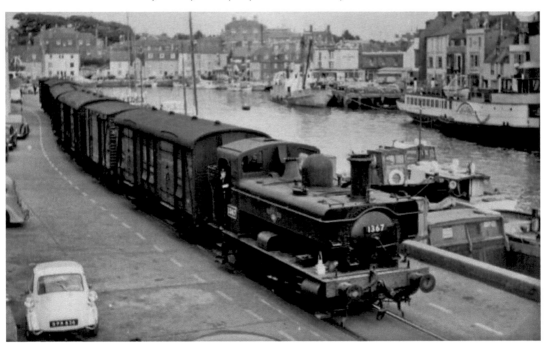

For many years passenger and goods trains were hauled through the streets by GWR Pannier Tanks. There is plenty of interesting styles of transport to be seen in the 1950s view, including a Cozens paddle steamer and a Heinkel bubble car.

When steam traction disappeared from Southern, Class 33 Cromptons were in charge of the boat trains. Tankers in the siding have brought fuel for the ship, and passenger accommodation on the platform is more basic than earlier years.

One of the many farewell specials was on 18 December 1994 when the Ocean Liners Express was hauled by Crompton No. 33116. Trains on the tramway had to travel at walking pace and were normally preceded by a lookout with a warning flag.

3. West Country Main Line

Due to Dorset's meandering northern border, part of the L&SWR West Country main line passed though the county. In 1847, the L&SWR decided that its prime route to the West Country would be from Basingstoke, aiming to reach Exeter, then hopefully Plymouth and Falmouth. Planning did not go smoothly as back in January 1845 the L&SWR had agreed with the GWR that it would not extend any line west of Salisbury. Initially the L&SWR opened a line from Basingstoke to Salisbury Milford in May 1857. However, Milford, to the east of the city, was not on the route west anticipated by the L&SWR, who planned a new station closer to the city centre. The Salisbury & Yeovil Railway was formed in August 1854 to build the next section of line. Work was initially undertaken at Gillingham where a turf-cutting ceremony was held on 3 April 1856. Services on the new single line commenced on 2 May 1859, operating into the L&SWR's new Salisbury station. When the line was being surveyed consideration was given on trying to serve Shaftesbury – the first town across the Wiltshire–Dorset border. This was difficult as the town was situated on top of a hill, so Semley (just in Wiltshire) was provided to serve Shaftesbury. Gillingham was a small market town and soon milk traffic developed at the station. The arrival of the railway also saw industry expand around the town. The next station on the line was Templecombe, but this lies within Somerset. Sherborne (in Dorset) was another market town that saw a growth in population following the arrival of the railway. Services from Salisbury commenced on 7 May 1860, reaching Yeovil Junction in June, extending to Exeter Queen Street (later renamed Central) the following month. Initially three trains a day served Exeter, with the 'Noon Express' taking 4¼ hours from Waterloo. The L&SWR operated the Salisbury & Yeovil Railway services, acquiring the railway on 1 February 1878, by which time most of the route had been doubled.

A branch to Lyme Regis was proposed in 1871, with a turf-cutting ceremony held in the town in September 1874, but nothing else happened. The Axminster & Lyme Regis Light Railway was formed in June 1899, with work starting the following summer. Slow progress delayed its opening until August 1903, with the branch reaching the main line at Axminster, Devon. Trains were worked by the L&SWR, who bought the branch on 1 January 1907. During the 1930s the holiday resort boasted a restaurant car express from Waterloo. However, for the majority of its existence two-coach trains were operated by Adams 'Radial Tanks', then Ivatt tanks, then finally by diesel units. The branch closed in November 1965.

The L&SWR became part of the new Southern Railway on 1 January 1923. N15 Class locomotives were introduced in 1920 on West Country trains, becoming the King Arthur Class in 1923 when given names relating to West County legends. The Atlantic Coast Express was introduced on 19 July 1926 to serve major Southern Region stations in Devon and Cornwall. Standard coaching stock was used, with the train named to counter the rival Great Western's Cornish Riviera. Increased demand on summer Saturdays saw the need to run four separate trains from Waterloo to cover all the destinations. Adverts in the 1930s for north Devon and north Cornwall holidays promoted luxurious corridor coaches and restaurant cars. Merchant Navy locomotives appeared during the Second World War on trains to Exeter, joined by West Country and Battle of Britain Class from October 1945. Being lighter than Merchant Navys, they could operate to Plymouth and most of the Devon and Cornish branches. They were planned to replace the existing Class N and U locos, but

they also remained in service. The Devon Belle Pullman train was introduced on 20 June 1947, normally hauled by a Merchant Navy, with twelve coaches plus an observation coach. Running from Waterloo, it split at Exeter with four coaches bound for Plymouth and eight for Ilfracombe, normally hauled by a West Country. The Plymouth portion did not prove popular and was dropped in September 1949, with the Ilfracombe portion continuing until September 1954. The Devon Belle was not as successful as the Bournemouth Belle, which catered for businesspeople, whereas Ilfracombe mainly attracted holidaymakers.

The Beeching Report of March 1963 resulted in many former L&SWR West Country branches closing. They had been provided with their business by trains from the main line, which was now in decline – no longer regarded as a trunk route. The Atlantic Coast Express was withdrawn on 5 September 1964 and steam was soon withdrawn. Diesels were introduced – Class 42 Warships plus DMUs for local services – with the line downgraded and coming under Western Region control west of Sherborne in 1963. This resulted in an emphasis on their services from Paddington to the West Country, with passenger numbers falling on the former Southern route and some of its stations closed in spring 1966. Local goods traffic disappeared during the 1960s, with through traffic using the Western main line. Then in 1967 the line between Wilton and Exeter was singled as it was regarded as a secondary route. Gillingham station became a passing place, with Sherborne remaining on a double-track section between Templecombe and Yeovil Junction. During the work, station sidings and signal boxes were removed. Class 33 Cromptons replaced the Warships in October 1971, but they were not really suitable and services declined further. Luckily new management thinking in the late 1970s resulted in gradual improvements, with Class 50s and newer coaching stock introduced from May 1980. Although electrification of the line had been considered at times, it never took place. As such, the route remains the only former Southern Region main line not to be electrified.

Timings and passenger numbers improved, with the line becoming the West of England Main Line of the new Network SouthEast in September 1986. It seemed odd that a sector named Network SouthEast should extend as far west as Exeter St Davids. The new operator gradually introduced Brush 47 diesels, which improved timekeeping. The line was upgraded in the early 1990s and new Class 159 three-coach turbo diesel units arrived in July 1993, supplemented by Class 158s. Network SouthEast continued until April 1994, becoming South West Trains, still with Class 158s and 159s. In August 2017, the lines franchise was taken over by South Western Railway, who normally provide an hourly service in each direction.

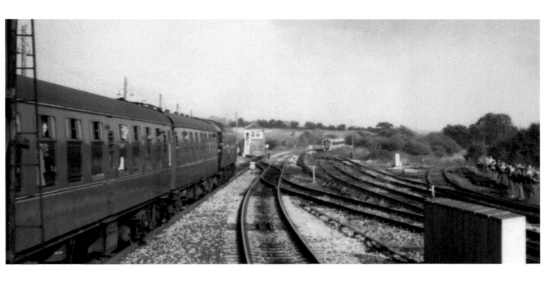

A view from Yeovil Junction, Somerset, looking east along the former L&SWR West of England Main Line. The Dorset border is just beyond the Class 158 unit in the carriage siding. Class 47 *Lady Godiva* departs with a rail tour on 8 October 1994.

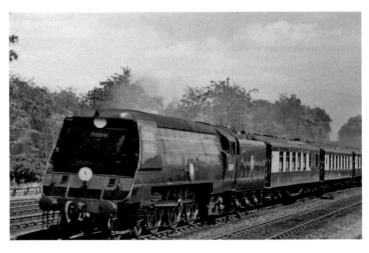

The West of England Line was famed for the Atlantic Coast Express and Devon Belle trains serving the West Country. The Devon Belle Pullman train operated in the early 1950s, seen here in charge of Merchant Navy No. 35019 *French Line CGT* bound for Plymouth.

Sherborne station in 2020 still retaining its original buildings. It's situated on a section of double track between Templecombe and Yeovil Junction, normally served by an hourly service in each direction.

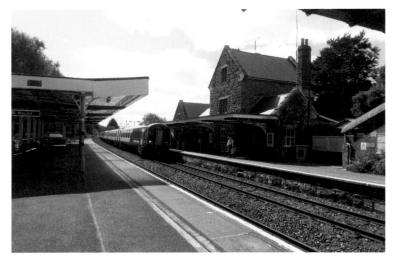

Class 159 South Western Turbo No. 159008 slows for its stop at Sherborne with a Waterloo-bound train in July 2020. There are probably fewer passengers than normal as this was the time of Britain's pandemic lockdown.

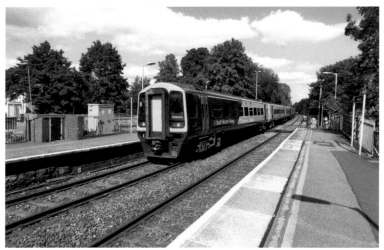

South Western Turbo No. 159005 departs Sherborne and heads over the level crossing en route to Gillingham and Salisbury. Passenger services were normally operated by two three-coach units coupled together, goods having long-since disappeared.

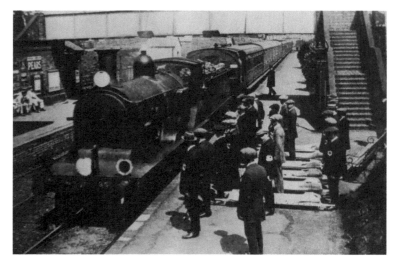

In charge of a L&SWR 4-4-0, an ambulance trains pulls into Gillingham during the First World War. Medical staff are on hand to collect the wounded troops prior to transferring them to emergency Red Cross hospitals in the town.

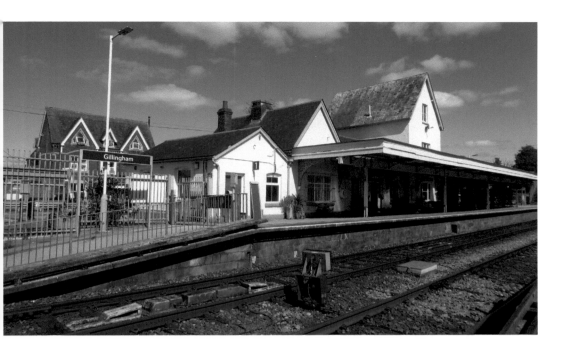

Gillingham station still has double tracks as it is a passing point on the West of England Line. Luckily it has also retained its original buildings, with a plaque marking the cutting of the first turf for the Salisbury & Yeovil Railway on 3 April 1856.

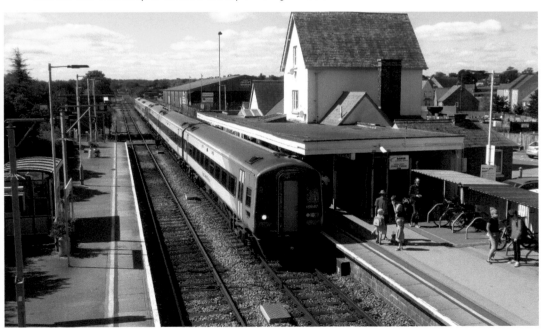

Arriving at Gillingham, South Western Turbo No. 159107 heads a service from Exeter to Waterloo in July 2020. The unit is still in basic South West Trains colours, with the rear unit in the replacement South Western Railway colours.

4. Somerset & Dorset

The Somerset & Dorset Railway was an amalgamation of the Dorset Central Railway and the Somerset Central Railway. The Dorset Central had been formed in 1860 to build a line from the south coast to the Bath or Bristol area. A start was made with a line from the L&SWR station at Wimborne to Blandford St Mary, which opened on 1 November 1860. The previous day a special train arrived at Wimborne from Waterloo carrying dignitaries and guests. They then transferred to a Dorset Central train for the inaugural journey to Blandford. The Dorset Central's plan for extensions northwards came to the attention of the Somerset Central, who had an existing line from Highbridge to Cole. So the Somerset Central approached the Dorset Central about joining forces to build the northward extension. This resulted in the formation of the Somerset & Dorset Railway (S&D) on 1 September 1862. Opened on 31 August 1863, the single line northwards from Blandford passed through Sturminster Newton and Templecombe (just north of the Dorset–Somerset border) where the line passed under the newly built L&SWR line to Exeter. Further impetus came in 1869 when the Midland Railway opened a line from Bristol into Bath (Green Park) – the S&D now had a northern terminus to aim for. Progress was slow and it was not until 1874 that the line to Bath was completed, with services commencing on 20 July.

From the opening of the Dorset Central in 1860, southbound trains would arrive at Wimborne facing Ringwood then had to reverse to reach Poole Junction and Poole/Hamworthy. At Wimborne, locomotives would change from a Dorset Central one to a L&SWR one before proceeding to Poole. Trains were able to run into Poole town from December 1872 with the opening of the line from Broadstone. With the extension of the line in 1874, the S&D were able to make Bournemouth West their southern terminus. Train reversal at Wimborne proved time consuming, so in December 1885 a cut-off was opened at the southern end of the line to join the L&SWR at Broadstone. Initially many trains still routed via Wimborne, but in due course the quicker route was preferred. So Wimborne, once an important station in the county, saw a reduction in passenger business, although goods remained. In summer 1865, the S&D offered Cheap Return Tickets via Poole Quay to Cherbourg. Passengers could travel from Bristol via Highbridge, from Cardiff via steamer to Burnham or from Templecombe on the S&D. Return fares were Templecombe 12s, Blandford 11s and Poole 7s 6d. Services to Cherbourg were available on the steamship *Albion*, then onwards to Bordeaux and the south of France. These shipping services did not prove successful.

Traffic on the S&D did not reach expectations, resulting in insufficient income to cover costs of the northern extension, with the S&D declaring itself bankrupt in 1875. The GWR considered taking over the line, but their proposal was rejected by the S&D. They then accepted a joint offer by the L&SWR and Midland Railway on 13 July 1876 to lease the line for 999 years. This did not please the GWR, who had seen it as an opportunity to reach Bournemouth and the south coast. Now known as the Somerset & Dorset Joint Railway, it was acquired outright by the L&SWR and Midland on 1 January 1892. In the 1880s there was an early morning Bath Express from Bournemouth West (forerunner of the Pines Express). Many services were operated by a fleet of S&D 'express' tank engines, Class A 4-4-0s and Fowler 0-6-0 tender engines. These were replaced in the 1920s by five Midland-designed tender engines.

The Midland Railway commenced a through service from Manchester London Road (now Piccadilly) to Bournemouth in October 1910. The train ran via Birmingham and Bath (Green Park), where it reversed to gain the S&D line southwards. The service was partly to counter a rival L&NWR service from Birkenhead to Bournemouth. Many holidaymakers used the Midland service for their annual holiday on the south coast. From 26 September 1927 the train gained the title the Pines Express – referring to the pines trees of the south coast. Posters showed 'Travel by LMS Pines Express from the North and Midlands'. There were also summertime connections from Liverpool and Sheffield. In summer 1934 the S&D advertised 'Attractive half-day excursions Bath to Poole & Bournemouth 5/-'. Later motive power would frequently be an LMS Black 5. However, a heavily loaded train, often with twelve coaches, would prove a problem over the steeply graded line over the Mendip Hills, where double heading would frequently be required. Goods traffic was mainly confined to the northern section of the S&D, with coal mines around Radstock. For this, the S&D had a fleet of Fowler 2-8-0 goods locos built in 1914 to haul the heavy trains. However, there was some goods workings through to Poole, with the Fowlers also used on summertime passenger trains.

Nationalisation of the railways came in 1948, with the S&D becoming part of the Southern Region. One result was the appearance of Bullied Light Pacifics on the S&D assisting the Black 5s. In later years there would be summer Saturday workings from Bradford, Cleethorpes, Derby, Nottingham, Sheffield and Walsall over the line. Local services continued to be operated by Fowler 4Fs & 2Ps. Then, in May 1954, a batch of new Standard Class 5s was allocated to the line, and 1960 saw the arrival of the first Standard 9Fs. These large locomotives were used to haul the heavy passenger trains over the Mendip Hills.

Under British Railways' revision of regional boundaries, the S&D line north of Templecombe was transferred to Western Region control in 1958 – southwards was still Southern. There was little co-operation between the two regions, resulting in fewer through trains. In fact, the Western Region did not want them operating over the S&D, withdrawing any expresses in September 1962. The final working of the Pines Express was 8 September and to mark the event it was hauled by Class 9F *Evening Star* – the final steam locomotive built for British Railways. *Evening Star* had arrived at Bath in August in anticipation of the event. Although expected to be double-headed over the Mendips, the crew took *Evening Star* over the route single handed. It was not the immediate end of the Pines Express as it now operated from Manchester to Birmingham and then via Basingstoke to reach Bournemouth, usually hauled by a Brush Class 47. It's terminus at Bournemouth West closed in October 1965, so the Pines ran through to Poole, its final service operating on 4 March 1967. The S&D had fallen under Dr Beeching's 1963 review. He noted the remaining local services were no longer profitable and, after many objections, the line was set to close on 3 January 1966. However, last-minute delays meant the S&D actually closed on 6 March, although Blandford remained open for goods until January 1969.

Around the former S&D route a number of groups dedicated to preserving its name appeared. In Dorset, the North Dorset Railway was formed in the late 1990s to restore Shillingstone station, which had survived demolition on closure of the S&D. The group set out restoring the track around the station for operations with diesel locos, ultimately planning to bring back steam. Further south, the Spetisbury Station Project cleared the old station site and restored the platforms. The route of the line between Sturminster Newton and Spetisbury now forms the North Dorset Trailway. The trailway passes the restored Shillingstone station; Blandford, where a set of buffers marks the site of the station; then passes the Spetisbury Project.

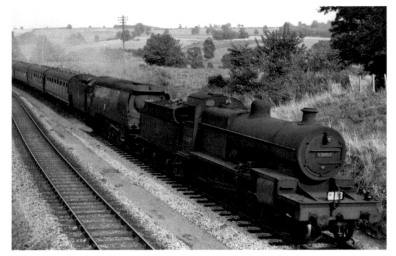

Heavily loaded express trains on the S&D frequently needed double heading to cope with the gradients over the Mendip Hills. Here S&D Class 7F No. 53807 pilots West Country No. 34040 *Crewkerne* on a southbound train in the 1950s.

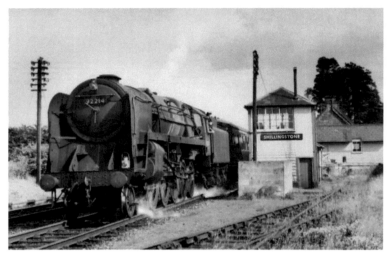

When the S&D 7Fs were withdrawn they were replaced by Standard Class 9Fs in 1960. Here No. 92214 pauses at Shillingstone with a northbound train in 1964. The original Dorset Central station building is on the Up side behind the signal box.

Luckily, the station building at Shillingstone survived following closure of the S&D in 1967. After a number of occupants, it was taken on by the North Dorset Railway Group in 2005 as part of the restoration of the whole station area.

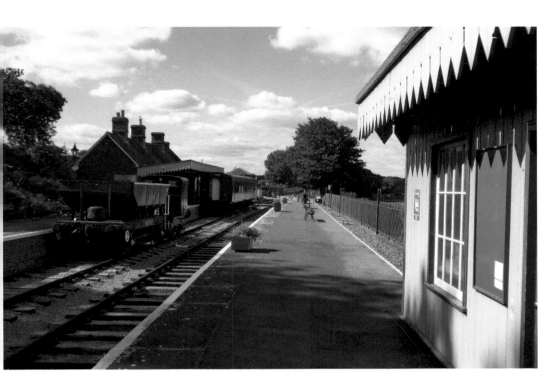

Thanks to the efforts of the North Dorset Railway, track and sidings have returned to Shillingstone, as seen in this August 2020 view. The aim is to extend the line northward and hopefully run limited steam services again.

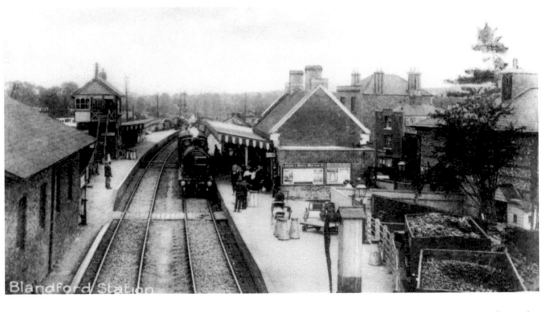

Blandford station, looking south in the 1920s. This replaced an earlier station when the Somerset & Dorset extended the line from Blandford to Templecombe in 1863. The small goods yard was situated behind the Down platform.

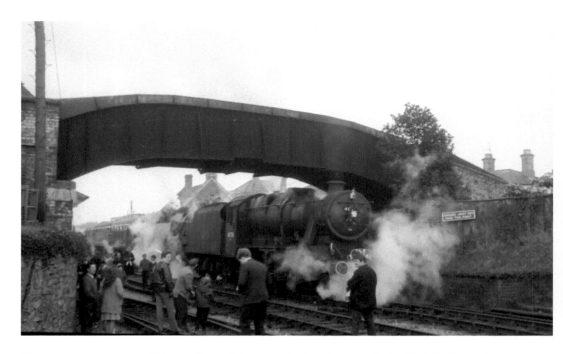

There were a number of farewell specials to mark the closure of the S&D Railway. Seen at Blandford, Stanier 8F No. 48706 and Standard Class 4 No. 80043 head north to Bath, with the final train over the line on 6 March 1966.

An August 2020 view shows the footbridge still in use. Underneath is a set of buffers and the station area was beyond, which has now been developed for housing. The land is part of the North Dorset Trailway, which follows the line northwards to Sturminster Newton.

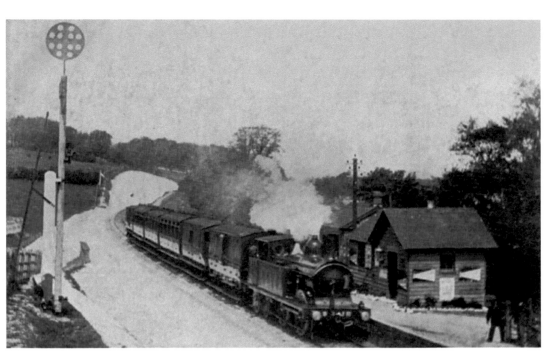

An early Somerset & Dorset service heading south through Spetisbury hauled by a 0-4-4 express tank loco. Note the early form of signal post on the left. Following closure, the platforms remained and form part of a restoration project.

The site of Spetisbury station in autumn 2020, which is now part of the North Dorset Trailway. The Station Project is restoring the area with plans to build replacement buildings and a signal box – the original S&D signal has already been replaced.

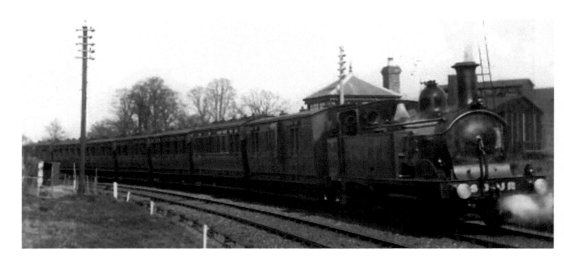

A S&D express tank shortly after leaving Wimborne and taking the curve northwards at Merley en route to Blandford. These tanks were used for many services in the early years of S&D operations. Their Wimborne loco shed is in the background.

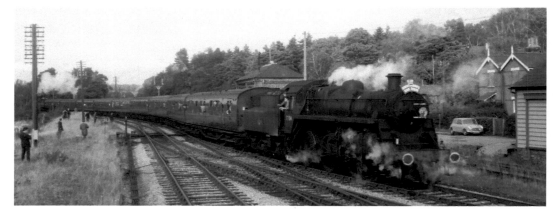

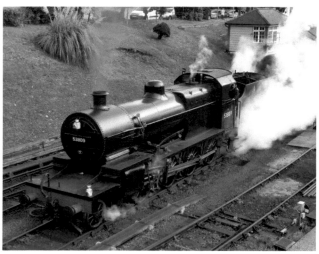

Above: A farewell special is seen at Broadstone in October 1966. Standard Class 4 No. 76026 disappears around the corner with a rail tour heading to Blandford. Standard Class 3 No. 77014 is at the rear, ready to head the train when it returns south.

Left: No. 53809 was one of the Fowler 7F goods locos built from 1914 to cope with the steep gradients over the S&D. Withdrawn prior to closure of the line, two of the class were luckily saved for preservation in the 1970s.

5. New Forest 'Direct'

With Bournemouth's population expanding in the 1880s the L&SWR decided it was time to improve services to the town. Plans were drawn up in 1883 for a direct route from Southampton, not having to travel via Ringwood. In anticipation of this the L&SWR built an imposing new Bournemouth station on the western side of Holdenhurst Road, which opened on 20 July 1885. The L&SWR were obviously looking to the future, with the station eventually being provided with four tracks and long platforms, plus a large engine shed at its western end. Its opening saw the original Bournemouth East station closed, becoming the town's goods depot.

After delays the final double-line section of the present-day main line across the New Forest was built between Christchurch and Brockenhurst, opening on 5 March 1888. The L&SWR directors arrived by special train, partaking of a grand lunch in the town. Three of the daily trains from Waterloo were expresses, completing the journey to Bournemouth in three hours. It was also realised that there needed to be a link between the two Bournemouth stations. So a connecting line was built between Bournemouth East and West, also coming into use on 5 March. Originally planned to be closer to the sea, objections from businesses and residents saw the line moved further inland, taking it over an imposing curved viaduct near Branksome station.

An adjacent viaduct was built at the same time to provide a direct connection between Bournemouth and Poole, but it was not brought into use until 1 June 1893 when this section of the route was opened. The date saw the opening of Branksome station, also serving Poole's expanding suburbs. The present Pokesdown station was originally opened as Boscombe in July 1886. Then Boscombe station was opened in 1897, resulting in the former becoming Pokesdown, with both serving Bournemouth's eastern suburbs. Pokesdown underwent a major rebuild during 1930/31, which saw it provided with four tracks as a passing point. On 1 May 1899, Bournemouth East was renamed Bournemouth Central – a name more fitting for its status.

Prior to the First World War there could be twenty trains a day on the 108-mile route between Waterloo and Bournemouth, with 1911 seeing the first two-hour running. Between 1890 and the First World War a number of services included Pullman coaches, which, surprisingly, didn't prove popular. A long-distance service from Birkenhead via Birmingham and Basingstoke commenced in July 1910, later joined by services from Bradford, Newcastle and York. Local services around Bournemouth were operated by 'motor trains' or steam railcars in the early 1900s. Bournemouth's Down platform was extended in 1928 to cope with increasing passenger numbers, capable of taking two trains at the same time. Holidaymakers increased during the 1930s, obviously disappearing during the Second World War, then reaching their peak in the 1950s, necessitating additional trains on Fridays and Saturdays. These would see up to twenty-two specials to Weymouth or Swanage. However the increased use of cars during the 1960s saw a gradual decline in holiday traffic.

The L&SWR had a final rail link to complete in the west of Poole, in June 1893. Crossing Holes Bay, this linked Poole directly with Wareham. Finally trains could run from Waterloo via Bournemouth to Dorchester and Weymouth over what is the present-day main line. Between Hamworthy and Wareham a basic station was opened at Holton Heath in April 1916 to serve the newly built Royal Naval Cordite Factory, which had a vast narrow-gauge rail network. Not opened to the public until 1924, the station remained open despite the

Admiralty factory closing in the 1990s. Although Wool was only a small village the arrival of the army at nearby Bovington in 1899 and then Lulworth Camps in 1918 saw an increase in military traffic. Wareham also became an important army garrison town during the First World War, resulting in many troop train movements. The army left the town for Bovington in 1922. Southern Railway promoted Wareham, Corfe Castle and Swanage stations as convenient for the Purbeck District and 'Hardy Country'.

Passenger services were operated by the likes of Adams X6, Drummond K10, S11 and T9 4-4-0s, with N15s introduced on Bournemouth and Weymouth trains in the early 1920s. Even M7 tanks were used on main-line services. Following the establishment of the Southern Railway in 1923 the N15s were given names, now the King Arthur Class, with the Lord Nelson Class appearing from early 1930s. Merchant Navy express locomotives with their streamlined shape were introduced during Second World War for use on Bournemouth and Weymouth services. The lighter West Country and Battle of Britain Class were introduced from the end of the war, also being used on the Weymouth line. The Merchant Navys underwent major rebuilds from 1956, followed by the West Countrys and Battle of Britains. In the 1930s, T9s, Class 700s and M7s served the Swanage Branch. Push-pull M7 tanks and two coaches were the mainstay of the branch until the mid-1960s when Ivatt tanks took over. Through services from Waterloo would be hauled by West Countrys.

The Bournemouth Belle Pullman train was introduced on 5 July 1931, initially running direct from Waterloo to Bournemouth Central hauled by King Arthurs. Later the service was amended to stop at Southampton Central and terminate at Bournemouth West. The Belle made the journey in two hours, hauled by a Merchant Navy from October 1946. The journey proved a test for the locomotive crew as the Pullman coaches were much heavier than normal coaching stock. Impending electrification of the Bournemouth line marked the end of the Bournemouth Belle, with Brush Class 47s taking over from steam in January 1967. However, their unserviceability saw Merchant Navys still drafted in at times. Indeed, there was hope that the final run on 9 July 1967 would be steam hauled, but the duty fell to a Class 47.

Another named train was the Bournemouth Limited, introduced in July 1929, running from Bournemouth to Waterloo non-stop. The train had started at Weymouth (four coaches), stopping at Wareham to collect two further coaches from Swanage, then collecting a further four at Bournemouth. Passengers had to book seats for the train (most unusual at the time) and the timing was two hours. Initially hauled by a King Arthur, Lord Nelsons soon took over in the 1930s. The Bournemouth Limited was suspended during the Second World War, being revived as the Royal Wessex in May 1951 at the time of the Festival of Britain. Timing from Bournemouth to Waterloo was two hours and twenty minutes as it made stops at Brockenhurst, Southampton and Winchester. It ran each morning from Weymouth to Waterloo, adding coaches from Swanage at Wareham. The return journey was early evening, with West Countrys in charge. However, in the early 1950s it was diesel hauled by former LMS No. 10000/01 and Southern No. 10201/02 for a while. By 1957 the thirteen-coach train was hauled by Merchant Navys, which managed to return to the two-hour timings. With the impending introduction of electric services, the express was withdrawn on 8 July 1967.

Upon nationalisation in 1948 the Southern Railway became British Rail's Southern Region. The former Great Western line into Weymouth came under control of the new Southern Region in 1950. British Rail advertised Weymouth as being served by refreshment car expresses from Waterloo and Paddington. It also promoted express trains from Waterloo, the daily 'Bournemouth Belle' and through trains from the Midlands and the North.

The Beeching Report of March 1963 hastened the withdrawal of steam traction from the Southern Region. The Bournemouth main line was regarded as a trunk route, but not the

section on to Weymouth. This resulted in the Bournemouth line being electrified during 1967. Services commenced on 10 July and Bournemouth Central was renamed simply Bournemouth. Bournemouth West ceased to be used from August 1965, although it was not officially closed until October. The majority of the track leading to the station remained as it served the coaching sheds and cleaning plant. A new depot was built in 1967 for servicing the new electric stock, becoming known in due course as Bournemouth Traincare Depot.

The section of line directly connecting the Central and West stations was also closed, although the viaduct remained. To reach the Traincare Depot trains now had to travel from Bournemouth Central to Branksome and then reverse. Boscombe station was closed in October 1965, although many thought that it should have been Pokesdown that closed. The final Southern Region steam passenger service was operated by Merchant Navy No. 35030 on the afternoon of 9 July 1967 with a Weymouth to Waterloo service. The final steam service was the Bournemouth to Weymouth goods that evening hauled by Standard No. 77014. After withdrawal many of the steam locomotives were stored at Weymouth shed, before being towed away to South Wales for scrapping – or preservation. Services from Waterloo were now operated by 4 REP four-coach electric units – usually in pairs – plus a 4TC set. However, it was not felt cost-effective to electrify the remaining section to Weymouth. So a London train of 4 REP + 4TC stock arriving at Bournemouth would split, with the TC coach units taken forward to Weymouth by Class 33 diesels, with the 4 REP returning to Waterloo plus coaches brought up from Weymouth. The 4 REPs eventually improved the Bournemouth services, occasionally reaching 100 mph on suitable stretches of track.

The introduction of Class 33 + 4TC services on the Weymouth line in July 1967 showed the inconvenience of Waterloo-bound trains still having to reverse into the original platform at Dorchester. So a new platform was built on the Up Weymouth curve in June 1970, although the original station buildings remained in use until the late 1980s. A modern station building was provided on the new Up platform in November 1987. The original GWR-built Weymouth station was demolished in 1986 and replaced by a more minimalist station with three platforms. This was sufficient for the reduced amount of holiday traffic.

In 1969, Wool's station buildings were demolished and replaced by a functional box-like structure. The army continued to use Wool for the transport of lorries and tanks on flat-bed wagons, reducing from the 2010s. The sidings were still used for sand traffic until around the same time. Moreton's buildings were also demolished, replaced by minimal waiting shelters, with its platforms lengthened in 1970. There were also changes at Poole in the early 1970s. The original station was replaced by a featureless box structure in 1971 and at the same time one of the level crossings was finally replaced by a bridge. Questions had been asked in Parliament back in November 1945 when the Southern Railway said it was considering the abolition of the crossings. Nothing happened and the second crossing remained for use by High Street pedestrians, having closed to vehicular traffic in the mid-1980s. Despite appearing to be well used the goods yard closed in spring 1972, although some tracks still remained fifty years later. The coach sidings were expanded, with a number of InterCity express services being extended from Bournemouth to Poole.

With a fall off in trade, the Poole Quay Tramway closed in April 1960, but the branch to Hamworthy Quay remained open, often seeing substantial business. Motive power would be Class 700, Q and Standard 76000s. The withdrawal of the B4s saw diesel shunters arrive as replacements, plus Class 33 diesels hauling the trains. Steel trains often operated daily in the 1980s, requiring haulage by two Class 37s. Other main-line diesels appeared on the trains, ending with Class 60s and 66s in the 2010s. The steel traffic eventually moved to road transport and coal traffic ended in 1985. There were plans in spring 1992 to close the branch, but Poole Harbour Commissioners agreed to take over the track within their

boundary. There was an increase in stone trains during the late 1990s, originating from Whatley Quarry in the Mendips. These became sporadic, finally ending in spring 2018, which could well be the branch's finale. A further indication was the fence erected across the track on the Network Rail/Harbour boundary. However, the branch was still being inspected during 2022, so could be regarded as only mothballed.

Following the end of steam, services to Swanage were operated by Hampshire diesel units, some of which ran from Bournemouth, although the majority started from Wareham. The summer services from Waterloo were hauled by Class 33 diesels. Despite the usual protests, the Swanage branch closed from 3 January 1972, with the track soon lifted. This was not the end of the line, however, as the Swanage Railway was formed by enthusiasts in May 1972 to reopen services. Limited operations began in 1979, with the re-laid line between Swanage and Corfe Castle opening in 1995. The first train arrived on 8 September in the shape of a Virgin Voyager. This was a one-off as much work was needed before the branch was officially connected to the main line in 2017. In April 2023 the Swanage Railway commenced services to Wareham with a heritage diesel unit.

On 'closure' of the line, the clay traffic sidings at Furzebrook remained in use. They were expanded in December 1978 to cater for oil piped in from nearby Wytch Farm. From 1990 the oil was piped all the way to Fawley refinery on Southampton Water, with clay traffic ending in 1992. However, there was a revival in 2005 with the distribution of newly found LPG from Wytch Farm. In the 1980s, Class 47s were used on oil trains, with Class 60s later hauling the LPG tankers to Avonmouth. Traffic continued until 2015 when it switched to road, the line being now fully in the hands of the Swanage Railway. Special steam and diesel events held by the Swanage Railway brought in a wide selection of visiting locomotives.

Long-distance services were provided by BR InterCity from 1966. Poole to Birmingham saw Hymeks in the 1970s, with Class 47s used on most other routes. Services to Bournemouth were operated from the likes of Edinburgh, Glasgow, Leeds, Liverpool, Manchester Piccadilly, Newcastle and York. Later these services were operated by Virgin CrossCountry, also with Class 47s prior to introduction of HSTs and then Class 221 Super Voyager units. The service was franchised to CrossCountry in November 2007, still with Super Voyagers. The year 2007 saw the rearrangement of long-distance services, with only Manchester Piccadilly being served directly. Passengers for other destinations now had to change at Birmingham New Street for other CrossCountry services. Weymouth was the destination of a number of long-distance trains, departing from the likes of Cardiff, Derby, Liverpool and Manchester. However, from September 2002 the services all terminated at Bournemouth.

British Rail's Dorset services were taken over by Network SouthEast in June 1986, becoming their South Western Main Line. The Weymouth line was finally electrified in 1988, seeing the introduction of Class 442 Wessex Electrics from 16 May. The initial plan called for the demolition of Bournemouth station and replacing it with a modern structure. Luckily this did not happen and finance was eventually found to restore the Victorian building. Poole was also provided with new station buildings during 1988, plus an extension of its platforms. The Network SouthEast operation continued until April 1994, when their franchise was taken over by South West Trains. The well-liked and patronised Wessex Electrics were withdrawn in February 2007 and replaced by Class 444 (express service) and 450 (local service) Desiro units. In August 2017, the franchise passed to South Western Railway, who continued to operate the Desiros.

The Covid-19 pandemic brought a reduction in services as many of SWR's core passengers were commuters who had decided to work from home. Services slowly returned to normal in the early 2020s.

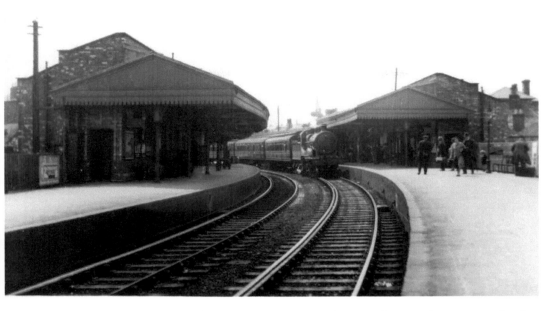

Poole station in the 1930s with an S&D train approaching. Built on a sharp curve, this has caused problems ever since. The original L&SWR buildings were demolished in 1971 around the time Old Poole town was being redeveloped.

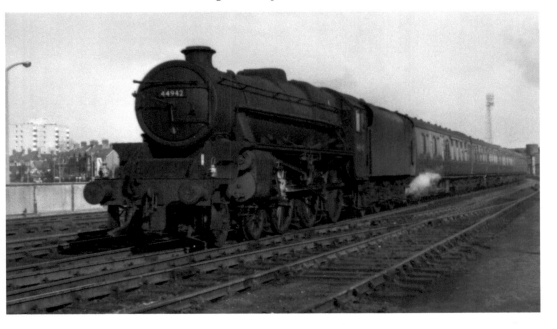

Inter-regional trains have always operated from the south coast to other regions. Stanier Black 5 No. 44942 has left the carriage sidings to the west of the station and arrives with empty coaches to work a northbound train, probably to Manchester.

The Holes Bay link between Poole and Hamworthy was opened by the L&SWR in 1893, enabling trains to operate directly between Waterloo, Bournemouth and Weymouth. Strengthening work on the embankment is under way in April 2017.

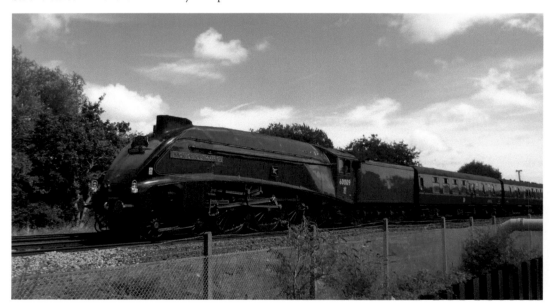

A4 No. 60009 *Union of South Africa* was a regular on the Dorset Coast Express between 2017 and 2019. Seen on 16 August 2017, it has just passed Poole on its way to Weymouth. The A4 was retired from main-line duties in March 2020.

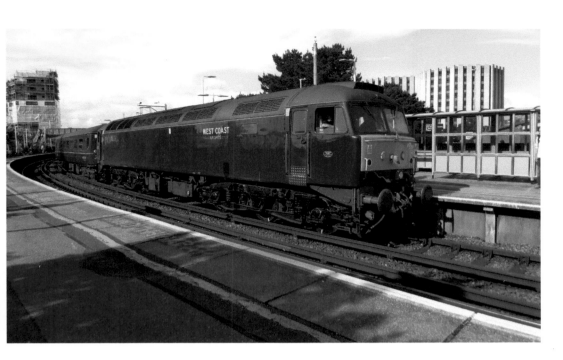

In later years specials didn't have to be steam – diesel traction was also in demand. Here Class 47 No. 47832 in West Coast Railways maroon livery waits departure from the sharp curve of Poole's platform with a charter on 31 May 2018.

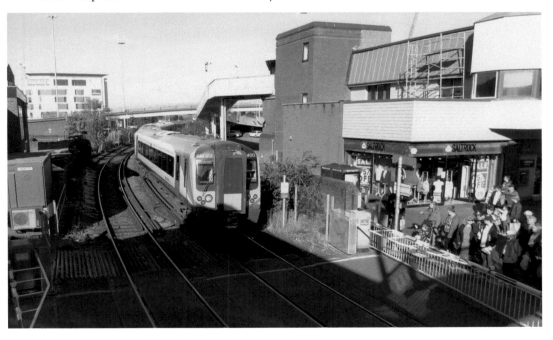

Poole's level crossings have always proved a problem, being so close together. One was replaced by a road bridge (just visible in the background) but the High Street one remains. Closed to vehicles in the mid-1980s, shoppers still cause problems.

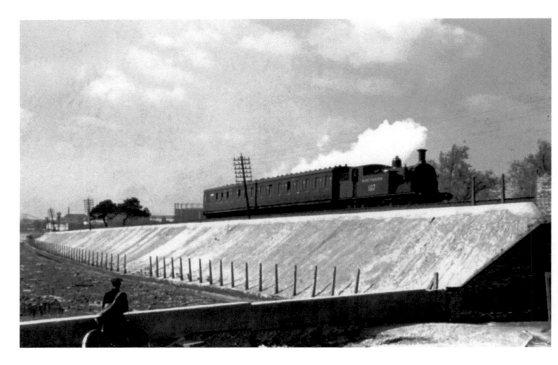

Another embankment was built to the east of Poole station passing Poole Park. Here M7 Class 107 on a push and pull working in the 1930s bound for Bournemouth West. The area of Poole Harbour to the left of the embankment was reclaimed in the 1960s.

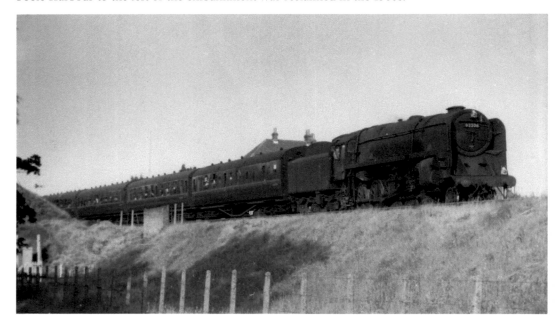

Standard 9F No. 92206 descends Parkstone Bank with a packed excursion train returning from Bournemouth West to Bath over the S&D. These large locos were drafted in towards the end of S&D operations to work the heavy trains over the Mendip Hills.

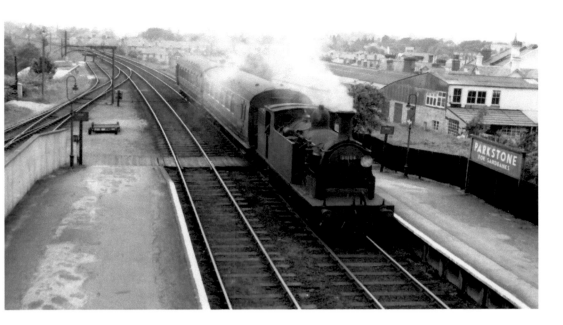

Arriving at Parkstone in the 1950s is M7 No. 30104 on a working from Brockenhurst to Bournemouth West via the original Castleman's Corkscrew route. The station was built to serve the expanding suburbs of Poole.

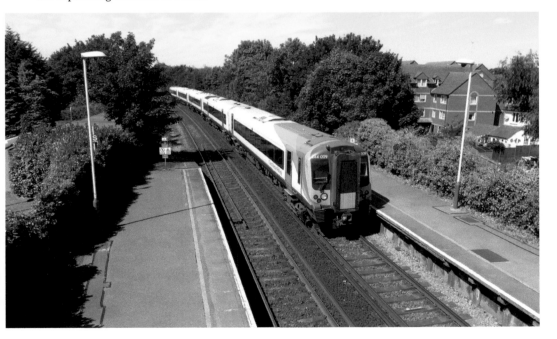

Desiro No. 444009 is in the same position as the M7, but the background has changed over seventy years. As in many locations the tremendous growth of trees is the main difference. These would have been cut back in the days of steam.

Crompton No. 33108 plus a 4TC set pauses at Parkstone prior to the Crompton pushing the TC set up Parkstone Bank on its way from Weymouth to Bournemouth. This style of operation continued until the line was electrified in 1988.

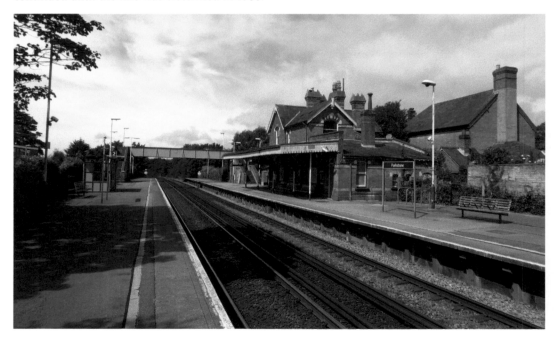

Luckily Parkstone's main Up side station building has survived, although the Down side only has the usual bus shelter for passengers. Modern Desiro units make light work of the bank through the station even compared to the likes of Bulleid Pacifics.

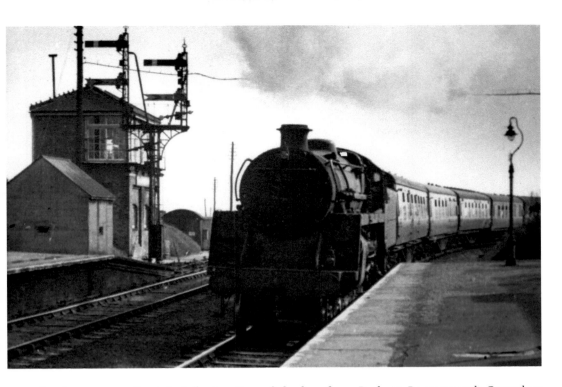

Branksome was situated at the junction of the line from Poole to Bournemouth Central or Bournemouth West. Seen approaching from Bournemouth West in the mid-1950s is Standard Class 5 No. 73052 on the Pines Express.

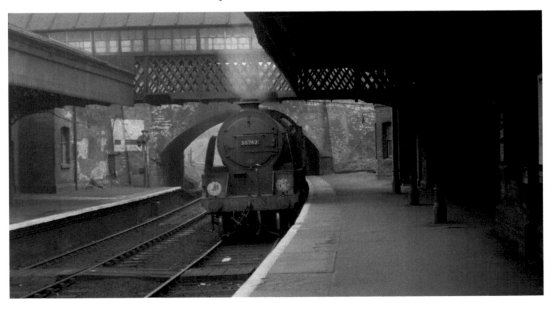

King Arthur Class No. 30742 *Camelot* passes under Poole Road bridge as it arrives at Branksome with a train from Weymouth. When it arrives at Bournemouth Central its coaches will be added to others already waiting for the journey to Waterloo.

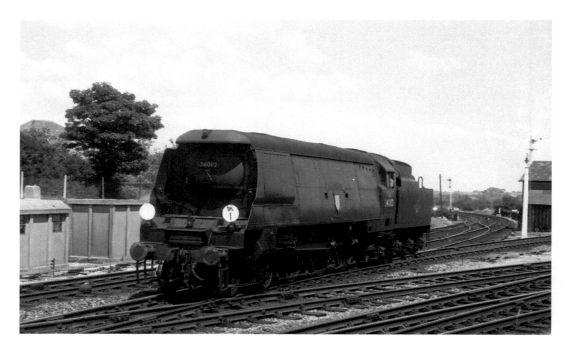

West Country No. 34002 *Salisbury* arrives with light engine from Bournemouth Central in August 1966, having worked a special from London. Branksome was always busy with locos using the adjacent triangle to turn, plus gaining access to the carriage sheds.

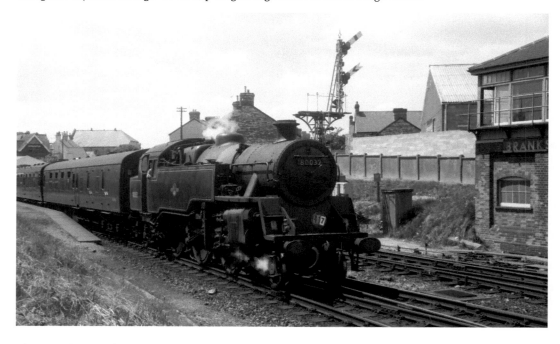

Closure of one side of the Branksome triangle brought more workings through Branksome. Stock of a London train has arrived, with Standard Class 4 No. 80032 attaching itself to the rear to take the coaches to the Bournemouth carriage sheds.

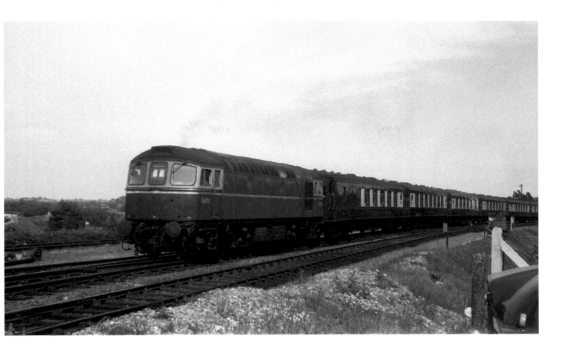

Crompton Class D6516 heads towards Branksome from the carriage sheds with empty stock for the Bournemouth Belle. At the station another loco will attach to the other end of the coaches to take them to Bournemouth Central.

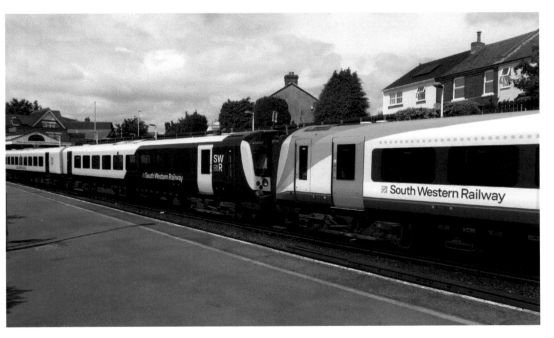

Changeover of colours on Class 444 Desiro units. In August 2017, South Western Railway took over South West Trains' franchise but took some time in repainting its units. No. 444007 is in full livery, but No. 444002 still has basic South West Trains colours.

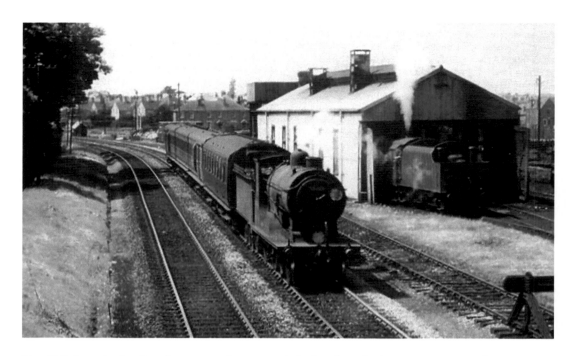

The S&D loco shed at Branksome was just around the bend on the line to Bournemouth West. Drummond Class S11 No. 30403 passes on a local service from Salisbury early in 1951, whilst a Midland Black 5 is on shed. There was a goods yard further to the right.

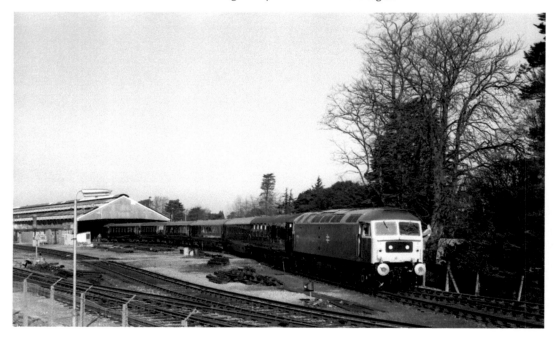

Bournemouth Traincare Depot with Class 47 No. 47539 reversing the royal train into the original shed. The royals were on a visit to Dorset in March 1979. The tracks in the foreground mark the site of the former main line into Bournemouth West.

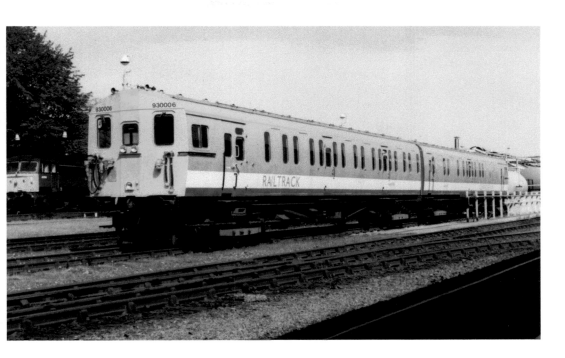

Railtrack Sandite De-Icing unit No. 930006 outside the Traincare Depot in May 1998. The unit was one of a number converted from four sub-electric units in 1979. They were based all over the Southern Region for use during frosty weather each winter.

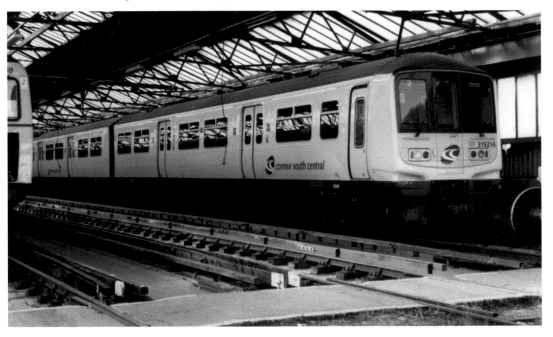

A visitor to the carriage sheds in 1998 was this newly refurbished Connex South Central Class 319 No. 319214. It is some way from its normal Victoria to Brighton route – indicated by its destination blind.

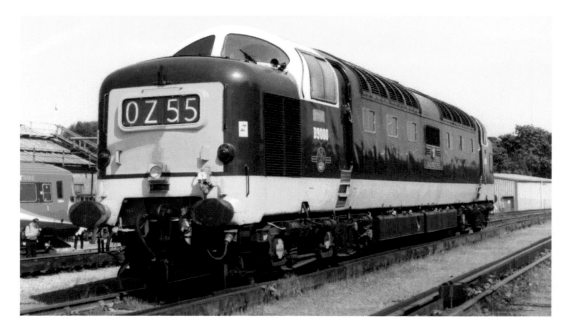

The Traincare open day on 16 May 1998 attracted a large number of visiting locos. These included preserved Deltic D9000 *Royal Scots Greys*, which was seen on other occasions on rail tours to Bournemouth or Weymouth.

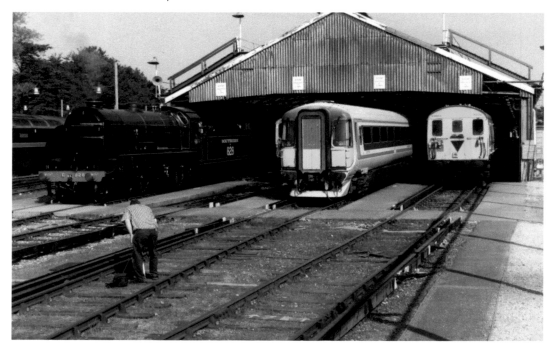

Further variety of motive power on display in the sheds on Traincare Depot's open day in 1998. Preserved Class S15 No. 828, a Class 442 Wessex Electric unit (based at the depot) and Railtrack Sandite de-icing unit No. 930201.

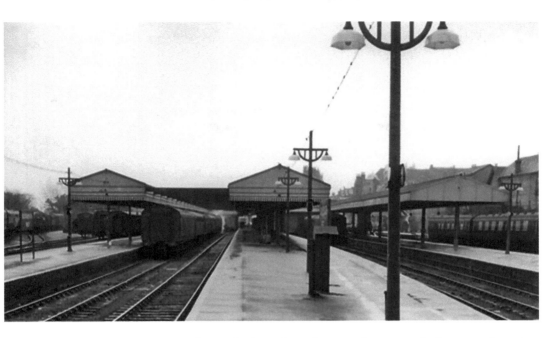

A rather deserted Bournemouth West looking along the main departure platform. Local services would normally use the platforms on the right. A Standard tank can be seen shunting in the carriage sidings to the left.

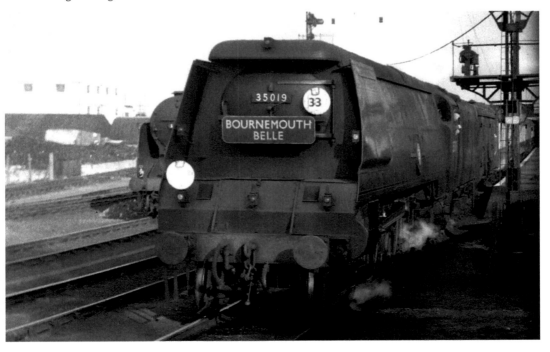

Merchant Navy No. 35019 *French Line CGT* prepares to depart for Waterloo with the Bournemouth Belle in summer 1957. The Pullman service continued to run until the end of Southern steam in 1967.

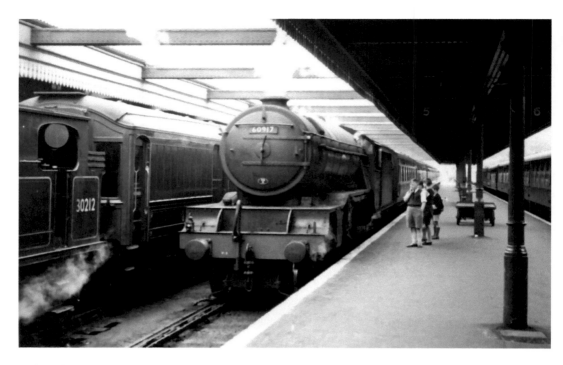

Definitely a stranger to Bournemouth. Merchant Navys were withdrawn for major repairs in 1953, with replacements brought in from other regions – hence the arrival of Eastern Region Class V2 No. 60917 from Doncaster shed.

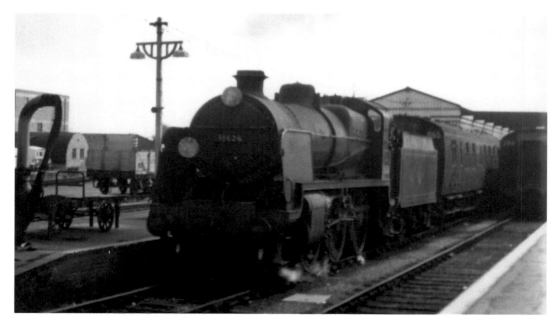

Class U No. 31626 departing in the late 1950s with a Salisbury train. Although due to be replaced by Standard Class locos, the Us soldiered on for a few more years on local services around Bournemouth. (RB)

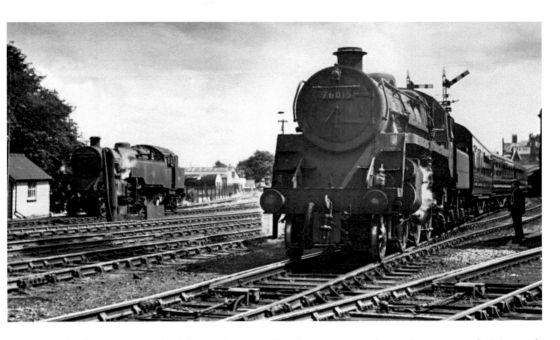

Standard Class 4 No. 76016 has a clear signal as it prepares to depart Bournemouth West with an S&D train. A Standard tank rests between duties in the carriage sidings. The Standards appeared from the mid-1950 to replace ageing Southern locos.

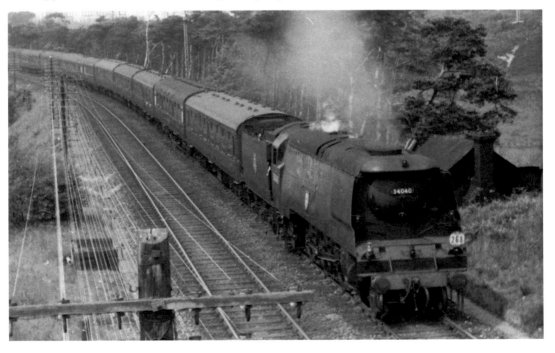

Heading east to Bournemouth Central, West Country No. 34040 *Crewkerne* passes Talbot Woods with a Weymouth express in the late 1950s. Behind the rear coach is the junction for the Bournemouth West or Poole lines. Both cross imposing viaducts.

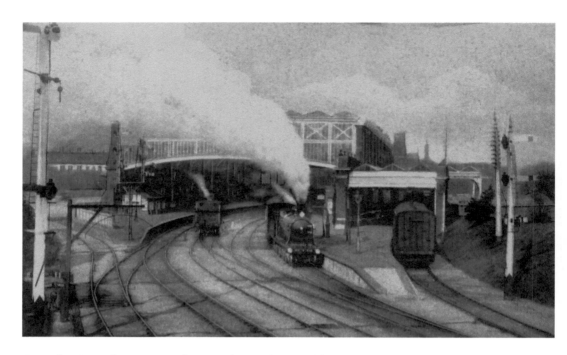

An early view of Bournemouth Central seen from Holdenhurst Road with a Waterloo-bound train just departing. This shows the four tracks originally provided plus, at the time, sidings at the London end of both main platforms.

Waiting in Bournemouth Central's Down platform is one of the L&SWR Motor Trains used on local services. The view shows the impressive roof provided by the L&SWR, resembling a Winter Garden building that was popular in Victorian times.

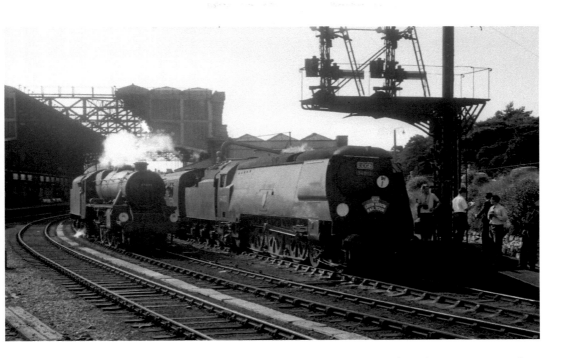

Stanier Black 5 No. 45493 and West Country No. 34002 *Salisbury* have just arrived at Bournemouth Central from Weymouth with a LCGB rail tour in August 1966. No. 45493 is making its way to the shed, leaving No. 34002 to take the train forward.

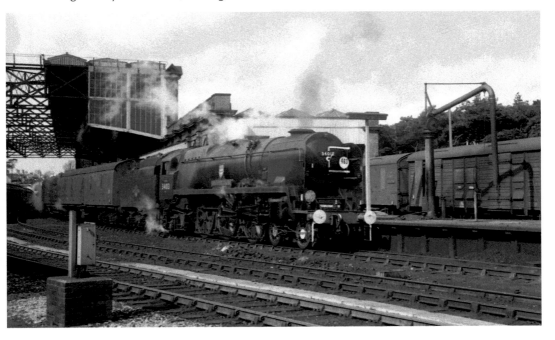

Towards the end of Southern steam a smart-looking West Country No. 34013 *Okehampton* prepares to depart for Waterloo. There are still four tracks through the station with the Up bay platform in use for parcel traffic.

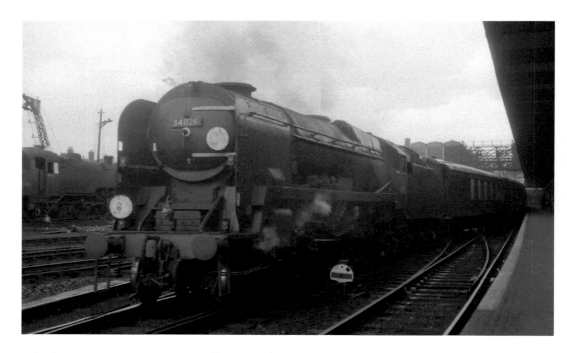

Rebuilt West Country No. 34026 pulls out of Platform 3 in March 1966 with the Bournemouth Belle bound for Bournemouth West. The points in the foreground gave access to Platform 4, which could be used at the same time as Platform 3.

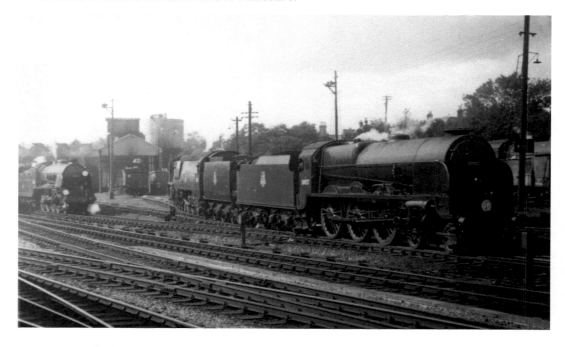

Train spotters had an excellent view of the engine shed from Platform 4 at Bournemouth. Seen here are a King Arthur and West Country along with Lord Nelson No. 30857 *Lord Howe*. The locos would work light engine to Bournemouth West to collect their trains.

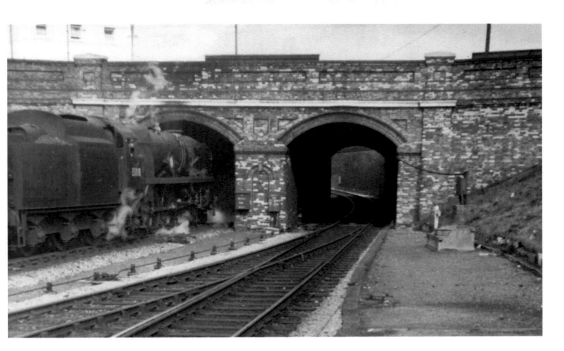

The first rebuilt Merchant Navy, No. 35018 *British India Line*, departs with a Waterloo-bound express. It is disappearing under Holdenhurst Road via what appears to be a bridge, but the L&SWR insisted that it be called a tunnel.

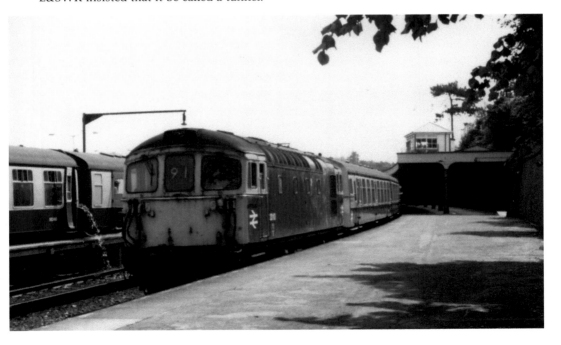

Crompton No. 33110 passes Platform 4 on its way to Weymouth with a 4TC set – the 91 code signifies a fast Waterloo to Weymouth service. To the locomotive's left the former main-line tracks have been converted to carriage servicing sidings.

When Bournemouth's Down platform was extended in 1928 the existing signal box was replaced by a new one in approximately the same location. This resulted in the new Platform 4 passing underneath it, with local housing close to the new box.

Preparing to depart from Platform 2 in 2003 on a northbound inter-region service is Virgin Cross Country HST No. 43102 *HST Silver Jubilee*. The area between the platforms which originally housed the two through tracks looks rather neglected.

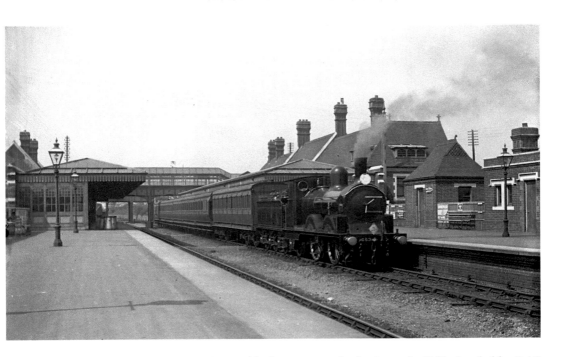

An Up train pauses at a rather deserted-looking Boscombe in the early 1900s headed by 0-4-2 Jubilee Class A12 No. 653. The station served the eastern suburbs of Bournemouth, being used by supporters of the nearby Bournemouth football ground.

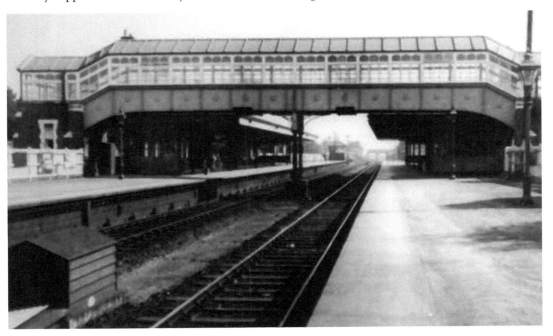

A view of Boscombe station looking east in the early 1900s, again with a lack of passengers. Surprisingly, it closed in autumn 1965, just prior to electrification of the line; there are calls for it to be reopened as the land is still available.

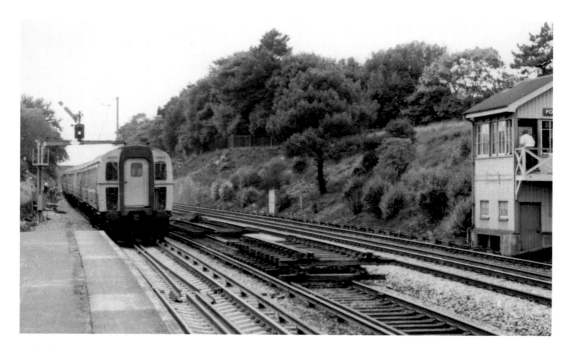

Pokesdown was rebuilt with four tracks in 1930 to provide a passing point for trains. These were not needed with the electrification of the line and the tracks were removed in 1972. 4 REP unit No. 3003 departs for Bournemouth.

On August 2020 a Class 444 Desiro has the all-clear to depart for Bournemouth, whilst a former Wessex Electric Class 442 approaches on the Up line. It's on driver training duty some way from its intended Waterloo to Portsmouth route.

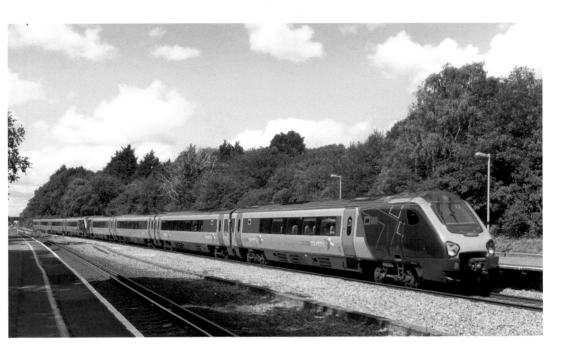

A CrossCounty Super Voyager passes Pokesdown on 3 August 2020 en route to Birmingham and Manchester. Passengers from the south now have to change at Birmingham New Street to reach destinations once serves direct by BR InterCity.

A view looking west towards Bournemouth from the footbridge showing where the passing tracks were situated and the curves in the existing line. This resulted in a speed restriction on all non-stop trains passing Pokesdown.

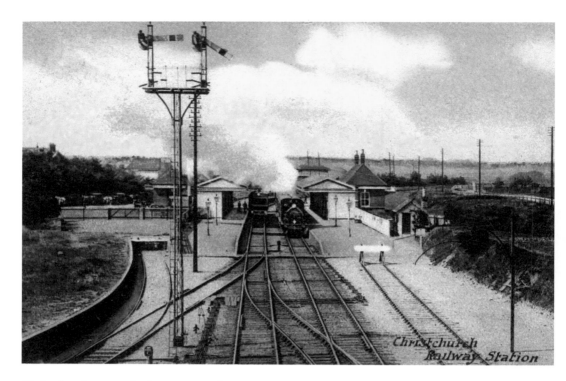

Christchurch station looking west in the 1890s. Two trains are passing, with the one approaching about to take the Ringwood line. Traffic on the Ringwood line dropped off with the opening of the direct route from Brockenhurst in 1888.

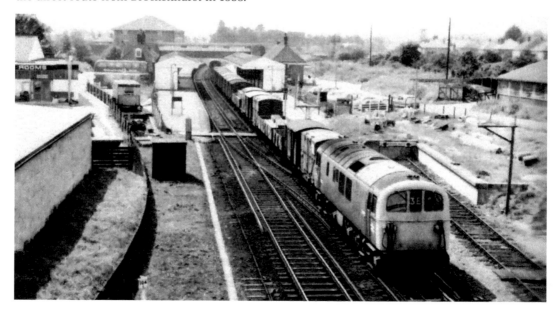

A more recent view of Christchurch from the same location. Class HB E6102 passes with an Up goods working in July 1972. Electrification of the main line made it less easy to handle goods traffic, which soon disappeared from Dorset.

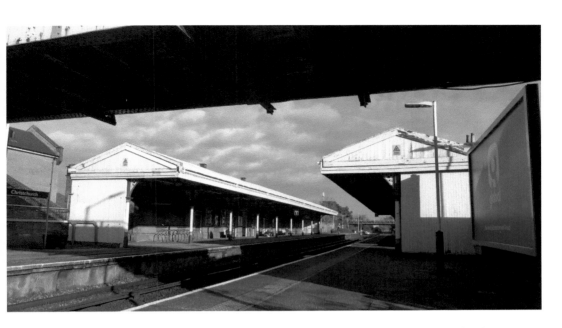

Christchurch has retained its original buildings and canopies, despite much redevelopment in surrounding areas; however, the signal box and goods yard are long gone. The station is usually served by four trains an hour.

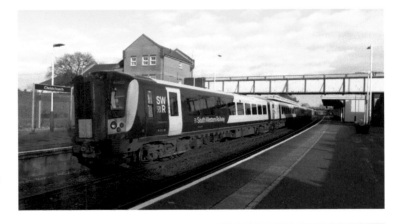

Class 444 Desiro No. 444021 of South Western Railway stops at Christchurch on a Bournemouth to Waterloo service on 8 December 2020. During the early 2020s these were the main trains to be seen on the Waterloo to Weymouth line.

Class 450 Desiro No. 450004 passes through Christchurch on 1 December 2020 with an empty stock working. Designed for use on local services they are seen less frequently than the express service 444 Desiros.

A CrossCounty Trains Class 221 Super Voyager passes Christchurch on 8 December 2020, nearing the end of its journey from Manchester Piccadilly to Bournemouth. CrossCountry took the route over from Virgin in November 2007.

Breaking the monotony of the normal Desiro units seen in the area, Freightliner Class 66 No. 66157 passes Christchurch on 22 October 2020. It was one of a number of driver training runs undertaken from Weymouth to Southampton. (TG)

As it should be on the Southern: shades of the Bournemouth Belle. Preserved Merchant Navy No. 35018 *British India Line* approaches Christchurch on a RTC special from Victoria to Weymouth on 6 June 2020. (TG)